LIFELIKE HEADS

By Lance Richlin

www.walterfoster.com

5 7 9 10 8 6 4

CONTENTS

INTRODUCTION

Here's some good news: There's no such thing as talent. Talent actually is a skill developed by combining good technique and practice. In the 25 years that I've been teaching, I've never had a student who didn't learn to draw after following directions and practicing. Of course, regular beatings are also essential.

If you're a beginner, you're about 60 heads away from being a good draftsman and about 100 away from being an expert. Here are three tips to help you get there:

1. You must *read* this book and follow the seven stages. Artists generally prefer to look at pictures only, but the words are essential to understand the pictures.
2. When you draw the 60 heads, spend between three and six hours on each one—don't just dash them off.
3. The portraits should be drawn from live models—not copied from photographs.

However, to avoid embarrassment and disappointment, you must practice from good photos for some time before persuading someone to sit for you. Once you can make an accurate drawing (without tracing) from a photo in three hours every time, you can move on to a live model. Of course, you can get started by copying all the drawings in this book.

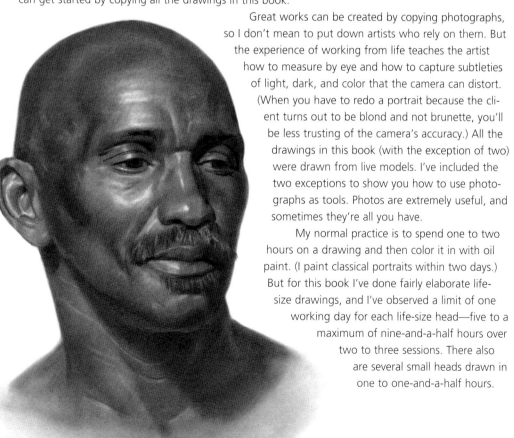

Great works can be created by copying photographs, so I don't mean to put down artists who rely on them. But the experience of working from life teaches the artist how to measure by eye and how to capture subtleties of light, dark, and color that the camera can distort. (When you have to redo a portrait because the client turns out to be blond and not brunette, you'll be less trusting of the camera's accuracy.) All the drawings in this book (with the exception of two) were drawn from live models. I've included the two exceptions to show you how to use photographs as tools. Photos are extremely useful, and sometimes they're all you have.

My normal practice is to spend one to two hours on a drawing and then color it in with oil paint. (I paint classical portraits within two days.) But for this book I've done fairly elaborate life-size drawings, and I've observed a limit of one working day for each life-size head—five to a maximum of nine-and-a-half hours over two to three sessions. There also are several small heads drawn in one to one-and-a-half hours.

MATERIALS & BASIC TECHNIQUES

Generally, graphite drawing requires a few simple tools, such as a pencil, eraser, and paper. However, my approach to this medium requires the small list of materials below. You don't need anything else to complete the projects in this book.

1. Woodless graphite pencils: 9B, 2B, and 5B
2. Staedtler® 8B pencil (to achieve matte blacks)
3. Stumps (smooth, not ridged)
4. A jar of graphite powder (store-bought isn't dark enough, so buy Design® Ebony Sketching Pencils (Matte Jet Black) and sand the tips into a jar; this will give you a powder that will create velvety blacks)
5. Powder puffs and eye make-up applicators for blending and applying graphite powder (you'll find they can be used for things stumps can't)
6. Kneaded, vinyl, and battery-operated erasers
7. A retractable, pen-shaped stick eraser
8. A knitting needle or ruler
9. Marker paper (at least 18 lb; thinner than this is too flimsy)
10. Bristol paper with a rough finish
11. A drawing board with clips to hold the paper or pad

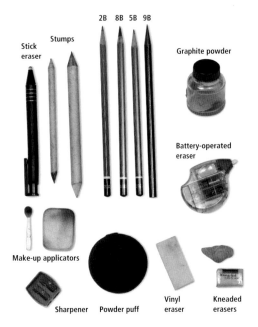

Paper

The two papers I use must be handled differently. The 18-lb marker paper is the best paper for heads smaller than a fist and can be used for life-size heads. The rough Bristol paper should never be used for small heads; the *tooth* (or raised areas of textured paper) will obliterate the detail. Marker paper is essential whenever speed is an issue because it automatically looks smooth and requires very little blending. The Bristol paper is excellent for large, time-consuming drawings. It is much more resilient, and the tooth absorbs graphite, which results in marvelous darks and blends. Unfortunately, the tooth also makes it necessary to continually blend the graphite to achieve smooth gradations. Please try both papers.

Shading

I always draw with the woodless 9B graphite pencil, switching to the 5B and 2B only for finer details. I respect using hatch lines for shading (see page 5), but I want my drawings to look a bit like black-and-white paintings—highly realistic. Therefore, I usually draw with the side of the graphite (A) and use the tip for fine detail and thin outlines (B).

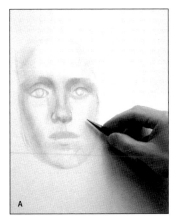

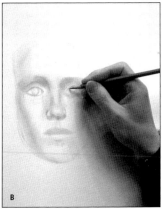

Below are a few methods for applying tone to your drawing, as well as examples of what to avoid when shading. Practice the recommended methods before you begin the projects so you can achieve clean, controlled tone in your drawings. Use whichever method adequately describes the form.

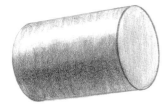

Shade Across the Form Create convincing form with pencil strokes that follow the width of the form.

Shade Along the Form You can achieve similar results by shading evenly along the length of the form.

Don't Shade Chaotically Don't use several directions of shading over the form—this is messy and uneven.

Hatching This involves applying parallel pencil strokes close together. This method is common, but I don't use it.

Don't Leave Gaps When shading with the side of the pencil, overlap each stroke to avoid separate bands of tone.

Avoid Using Uneven Pressure Shade with the same amount of pressure through an area—caress, don't slash.

Stumping

After laying in a form's proportions, outlining it, and shading it (stages 1–5; see pages 28–33), switch to a stump or a make-up applicator to blend and deepen the tones of the shadows. When the stump becomes coated with graphite, you can occasionally use it as a pencil.

A

Rubbing and Adding Highlights

After outlining, shading, and stumping the shadows, rub the entire drawing with a powder puff, and pull out highlights with a kneaded eraser. (For pure white highlights, I gently use a battery-operated eraser.) Rubbing can be dangerous because artists tend to rub too early in the development of the drawing, which causes the drawing to look messy and lack precision. On the other hand, rubbing is almost indispensable for finishing a drawing on white paper. I've tried shading up to the highlights and stopping, but rubbing is more efficient. Here are the rules for rubbing: (1) Wait until the drawing is three-quarters of the way finished; (2) rub enough graphite over the light areas so you can see the difference when you pull out the highlights. (Don't be perturbed if you have to re-darken areas that become bland after they're smeared.)

B

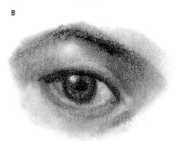

Creating a Polished Look Stumping and pulling out highlights provide a smooth and realistic finish. Compare the eye before (A) and after (B) stumping and pulling out highlights.

SHADOWS & HIGHLIGHTS

Below is a diagram that demonstrates the breakdown of light and shadow across a form. All forms—from faces and clothing to hills in a landscape—feature the same elements. In graphite drawing, these elements are represented by *tone* or *value* (the lightness or darkness of a color or of black). The more accurately your tones reflect the shadows and highlights of a form, the more you will convince the viewer of its three-dimensionality.

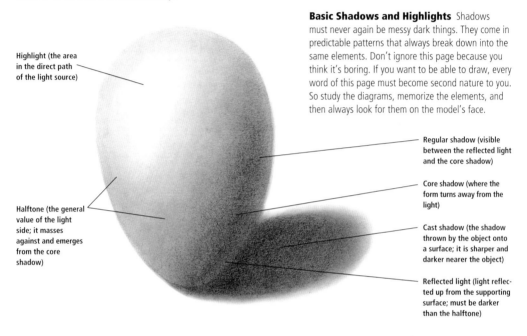

Basic Shadows and Highlights Shadows must never again be messy dark things. They come in predictable patterns that always break down into the same elements. Don't ignore this page because you think it's boring. If you want to be able to draw, every word of this page must become second nature to you. So study the diagrams, memorize the elements, and then always look for them on the model's face.

Highlight (the area in the direct path of the light source)

Halftone (the general value of the light side; it masses against and emerges from the core shadow)

Regular shadow (visible between the reflected light and the core shadow)

Core shadow (where the form turns away from the light)

Cast shadow (the shadow thrown by the object onto a surface; it is sharper and darker nearer the object)

Reflected light (light reflected up from the supporting surface; must be darker than the halftone)

Shadows and Highlights of the Head I deliberately kept this drawing in halftone (a middle value of graphite) so you can see the elements of shading more easily. Leaving out the darkest darks hurts me, so make my sacrifice worth it and study this diagram.

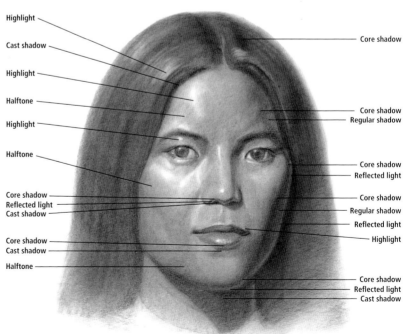

Highlight

Cast shadow

Highlight

Halftone

Highlight

Halftone

Core shadow
Reflected light
Cast shadow

Core shadow
Cast shadow

Halftone

Core shadow

Core shadow
Regular shadow

Core shadow
Reflected light

Core shadow
Regular shadow
Reflected light

Highlight

Core shadow
Reflected light
Cast shadow

HOW TO LIGHT THE MODEL

Always use only one dominant light on your model. It's okay to have some general light in the room, but several competing lights directed at the model will create forms that are flat or hard to read. Below are two drawings of the same woman done with two different lighting styles that were practiced by two master artists: Rembrandt and Van Dyke. One creates a harsh look with distinct shadows and more contrast (Rembrandt's high-contrast side lighting), whereas the other produces a more feminine, delicate image (Van Dyke's low-contrast front lighting).

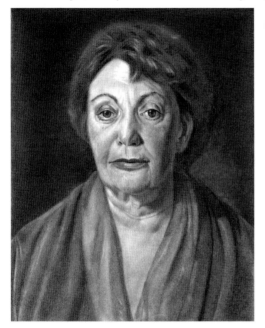

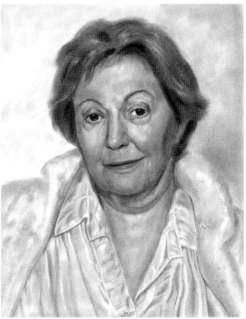

Side Lighting When drawing this portrait, I worked in a dark room with one light positioned to the model's right. Rembrandt often used this type of lighting for his portraits. This style makes the model look older and more serious, as the contrasts create harsh shadows, deepening and creating lines on the face and neck. This type of lighting is best for giving a model an air of power and gravitas. (See page 59 for another example of high-contrast lighting.)

Front Lighting Van Dyke used a different method of lighting his models, which involved using a well-lit room with one light positioned in *front* of the model. Ingres, another great portraitist, learned to use this lighting style in order to reduce shadows across the model, resulting in more flattering portraits of their clients. (When using this method, position the light as far away as possible to avoid hurting the model's eyes.)

Enhancing Expression

To emphasize the characteristics brought out by each type of lighting, I employ the following tricks:

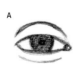

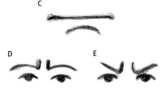

Be careful with slight smiles—they tend to look odd. Try to be a little bolder and make your smiles unambiguous. In the front-lit drawing, I created a clear, gradual arc for the lips.

I also raised the lower eyelids so the bottom of the iris is a bit flattened (A), which suggests a smile. In contrast, showing the bottom of the iris creates a serious eye (B).

The model's intelligence is emphasized in the side-lit drawing by the pushing up of the lower lip in judgement (C) and by the furrow between the eyes (D). I'm careful not to lower the eyebrows—this would make her look mean (E).

ANATOMY

Knowing the anatomy of the head will help you understand the basic forms beneath the skin. Listing the names of the points on the skull isn't practical for our purpose here. Instead, I've placed a dot at each point of the skull that you should be aware of when you draw. These points make an impression on the surface, and, if you include them, your drawings will be more accurate.

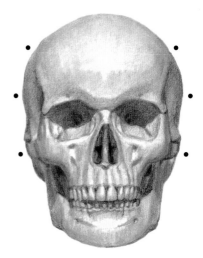

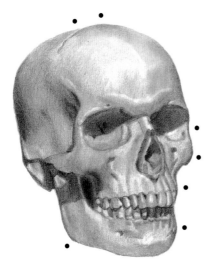

The diagram directly below includes the *temporalis* (on the temple) and the *masseter* (on the jaw) muscles. These muscles allow you to chew by pulling the jawbone. The illustration below right is a general (though not complete) diagram of the facial muscles so you can see the shapes of the muscles that lay over the bone.

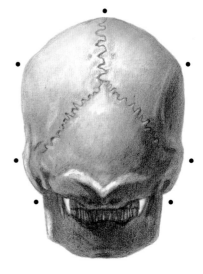

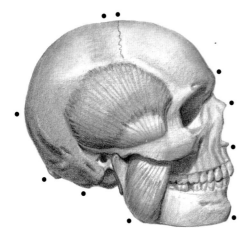

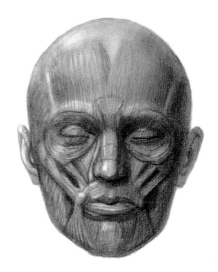

Facial Muscles and Expression

Below is a list of the most important muscles used in facial expressions. Familiarizing yourself with them will help you understand how the muscles move to affect the shapes and bulges of the skin.

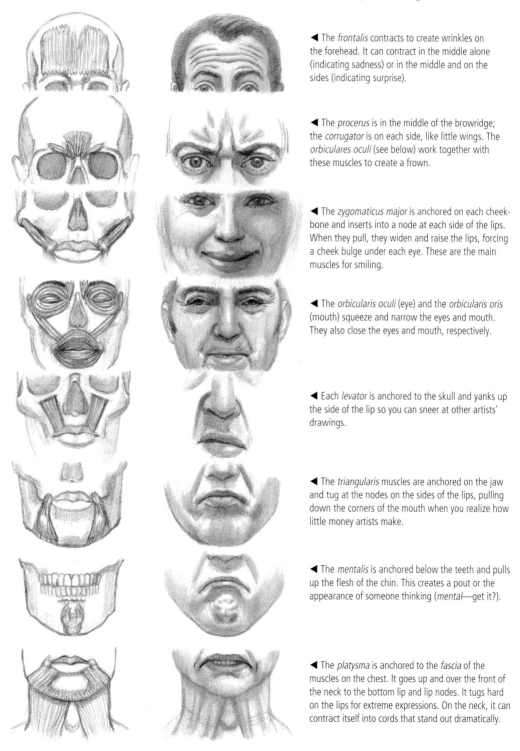

◄ The *frontalis* contracts to create wrinkles on the forehead. It can contract in the middle alone (indicating sadness) or in the middle and on the sides (indicating surprise).

◄ The *procerus* is in the middle of the browridge; the *corrugator* is on each side, like little wings. The *orbiculares oculi* (see below) work together with these muscles to create a frown.

◄ The *zygomaticus major* is anchored on each cheekbone and inserts into a node at each side of the lips. When they pull, they widen and raise the lips, forcing a cheek bulge under each eye. These are the main muscles for smiling.

◄ The *orbicularis oculi* (eye) and the *orbicularis oris* (mouth) squeeze and narrow the eyes and mouth. They also close the eyes and mouth, respectively.

◄ Each *levator* is anchored to the skull and yanks up the side of the lip so you can sneer at other artists' drawings.

◄ The *triangularis* muscles are anchored on the jaw and tug at the nodes on the sides of the lips, pulling down the corners of the mouth when you realize how little money artists make.

◄ The *mentalis* is anchored below the teeth and pulls up the flesh of the chin. This creates a pout or the appearance of someone thinking (*mental*—get it?).

◄ The *platysma* is anchored to the *fascia* of the muscles on the chest. It goes up and over the front of the neck to the bottom lip and lip nodes. It tugs hard on the lips for extreme expressions. On the neck, it can contract itself into cords that stand out dramatically.

Muscles of the Neck

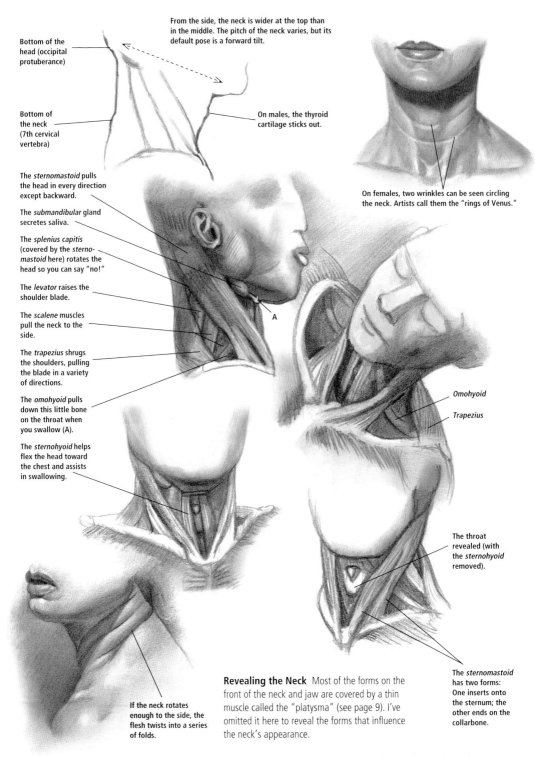

From the side, the neck is wider at the top than in the middle. The pitch of the neck varies, but its default pose is a forward tilt.

Bottom of the head (occipital protuberance)

Bottom of the neck (7th cervical vertebra)

On males, the thyroid cartilage sticks out.

On females, two wrinkles can be seen circling the neck. Artists call them the "rings of Venus."

The *sternomastoid* pulls the head in every direction except backward.

The *submandibular* gland secretes saliva.

The *splenius capitis* (covered by the *sternomastoid* here) rotates the head so you can say "no!"

The *levator* raises the shoulder blade.

The *scalene* muscles pull the neck to the side.

The *trapezius* shrugs the shoulders, pulling the blade in a variety of directions.

The *omohyoid* pulls down this little bone on the throat when you swallow (A).

The *sternohyoid* helps flex the head toward the chest and assists in swallowing.

A

Omohyoid

Trapezius

The throat revealed (with the *sternohyoid* removed).

If the neck rotates enough to the side, the flesh twists into a series of folds.

The *sternomastoid* has two forms: One inserts onto the sternum; the other ends on the collarbone.

Revealing the Neck Most of the forms on the front of the neck and jaw are covered by a thin muscle called the "platysma" (see page 9). I've omitted it here to reveal the forms that influence the neck's appearance.

These corpses were the best models I ever worked with; not because they held still but because they laughed at all my jokes.

PLANES OF THE HEAD

It's helpful to approach the head with a general idea of what can be expected. After decades of experience, I automatically check for the basic forms and plane changes described below. I would have saved a lot of time if I had memorized the planes of the head at the beginning of my career.

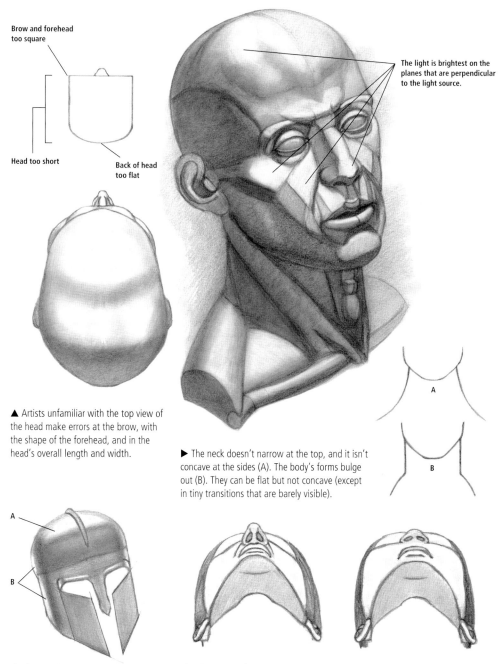

Brow and forehead too square

Head too short

Back of head too flat

The light is brightest on the planes that are perpendicular to the light source.

▲ Artists unfamiliar with the top view of the head make errors at the brow, with the shape of the forehead, and in the head's overall length and width.

▶ The neck doesn't narrow at the top, and it isn't concave at the sides (A). The body's forms bulge out (B). They can be flat but not concave (except in tiny transitions that are barely visible).

A

B

A

B

The face wedges toward the nose like this helmet. Notice the exaggerated highlights (A) and reflected light (B) on the metal.

This illustration of a Caucasian male shows how the face wedges toward the center.

This illustration of an Asian male shows a flatter face and sharper angles at the sides of the head.

GENERAL PROPORTIONS

Proportion (the comparative sizes and placement of parts to one another) is key to creating a likeness in your drawing. Although proportions vary among individuals, there are some general guidelines to keep in mind that will help you stay on track. Before you study the diagrams and tips below, memorize these two most important guidelines:

1. The face is usually divided into thirds: one-third from the chin to the base of the nose, one-third from the nose to the browridge, and one-third from the browridge to the hairline.
2. The midpoint of the head from the crown to the chin aligns with the tear ducts.

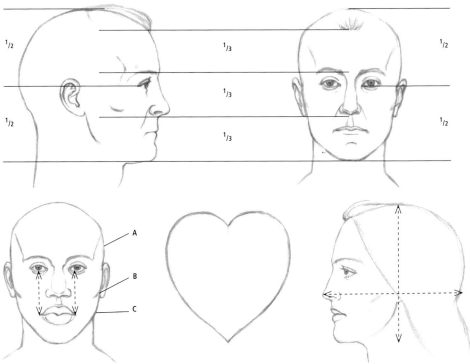

The mouth is usually the same width as the distance between the pupils. This particular model's tear ducts are higher than the midpoint.

Heads are somewhat heart shaped. The temple (A) is wider than the cheekbone (B), which is wider than the jawline (C).

Generally, the distance between the tip of the nose and back of the head is longer than the distance from the top of the head to the bottom of the head.

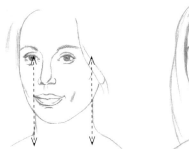

To determine the width of the neck, use the features directly above each side of the neck to serve as a guides for placement. To easily see this, hold up your pencil vertically in front of you, lining it up with the side of the model's neck.

Proportion Subtleties

- *The neck pitches forward slightly.*

- *The neck doesn't narrow as it goes up to the jaw.*

- *You can usually fit another eye between the eyes.*

- *If you've diligently measured and the model's face is asymmetrical or involves different proportions than I've given here, that's okay. These are guidelines—not strict rules.*

Shifts in Guidelines

When drawing the tilted head, it's essential to first measure to find the midpoint to see where it has shifted (A). Next draw lines to indicate the new positions of the features (B). I apply a bit of shading because horizontal lines alone aren't enough for me to judge by. I once knew a boy who didn't use steps A and B, and he was carried away by a troll.

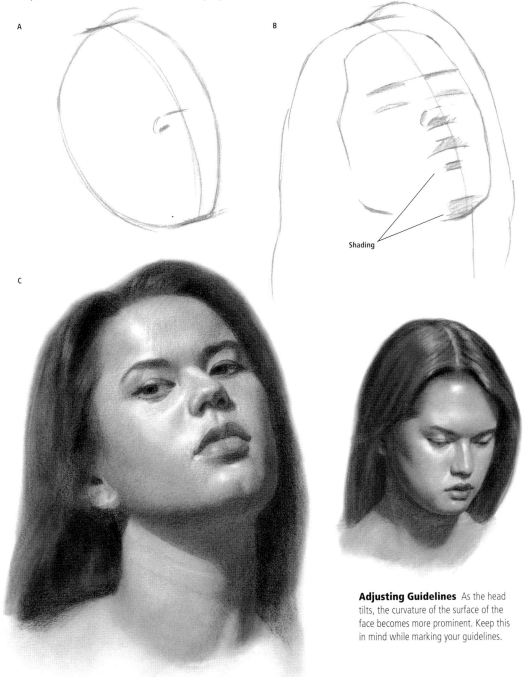

A

B

Shading

C

Adjusting Guidelines As the head tilts, the curvature of the surface of the face becomes more prominent. Keep this in mind while marking your guidelines.

FACIAL FEATURES

Now that you are acquainted with the basic forms and proportions of the head, let's examine the individual features that make up the face.

Ears

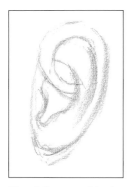 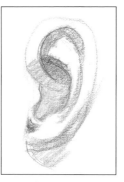 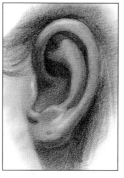 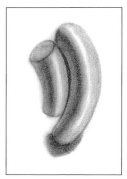

Step 1 Draw a rough lay-in of the ear.

Step 2 Then apply tone to indicate the shadows.

Step 3 Stump and then lift out highlights to polish.

Each form has core and cast shadows and highlights.

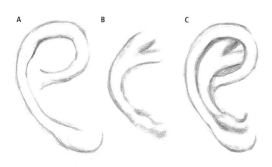

Memorize shapes A and B; combine them to create C. This gives you a basic outline to work with.

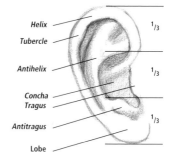

- Helix
- Tubercle
- Antihelix
- Concha
- Tragus
- Antitragus
- Lobe

1/3
1/3
1/3

The ear is shaped like a disk that is divided into thirds.

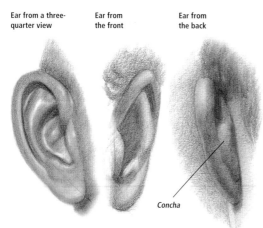

Ear from a three-quarter view

Ear from the front

Ear from the back

Concha

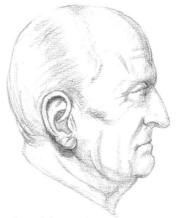

Elderly people usually have much larger ears and noses. Don't put a teenager's ear on an elderly person like I once did on an important commission.

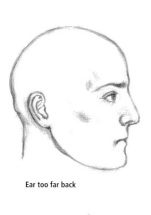

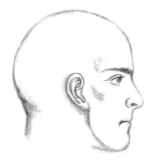

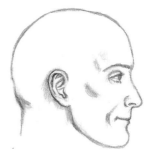

Ear too far back

Ear too far forward

Ear is just right, so he's happy.
Make all your drawings happy!

▶ The ear is situated between the brow and the base of the nose. It tends to be more in line with the lower part of the eyebrow, not the arch.

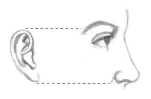

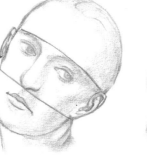

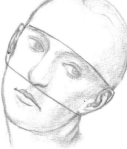

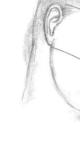

▶ There's a soft transition of the jaw from the lobe to the neck. The back of the jawline isn't sharp.

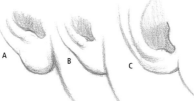

A B C

▲ Earlobes can hang (A), be attached (B), and even be underdeveloped (C).

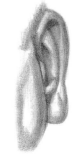

▶ People who are overweight often have lobes that are pushed out from their faces.

▶ A baby's ears are said to be rounder than an adult's, but I haven't noticed it. They do seem to be more concave.

Ears have a confounded habit of having extra forms. Notice the doubled helix and two lumps on this lobe.

15

Eyes

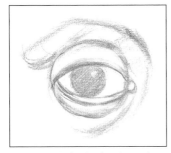

Step 1 Lay in the size, location, and folds of the eye.

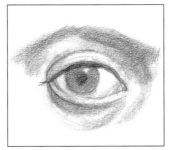

Step 2 Build the volume by adding tone for the form and cast shadows.

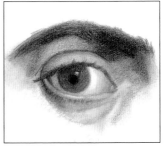

Step 3 Stump, pull out highlights, and give clarity to edges.

When drawing the eye, always begin by drawing a sphere and wrapping the lids over it.

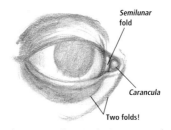

Semilunar fold

Carancula

Two folds!

There are two forms in the inner corner of the eye; hence there are two highlights!

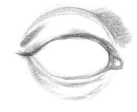

The outer corner of the eye is usually higher than the inner corner. The upper lid overlaps the lower lid at the outer corner.

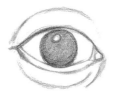

If you take my class, you'd better not show the top of the iris! This looks unnatural.

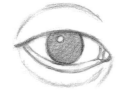

The lid should always partially cover the top of the iris.

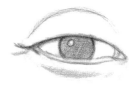

When a person smiles, even more of the iris is covered (especially at the bottom).

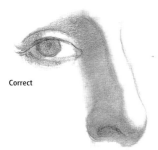

Correct

To correctly place the eye in relation to the nose, there must be a side plane between the nose and the eye.

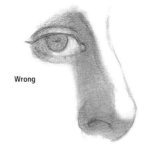

Wrong

Students often make the mistake of letting the eye creep up the side of the nose.

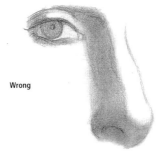

Wrong

Students also often place the eye at the top of the nose. The eye is to the *side* of the nose.

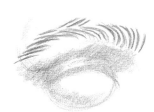

▲ The eyebrows start vertically and end horizontally.

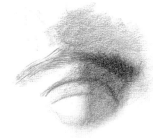

▲ The eyebrow is rarely the same tone all the way across because it's located on both the front and side of the face.

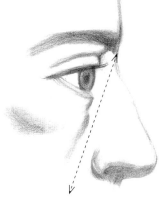

▲ There's a clear diagonal from the brow to the cheek.

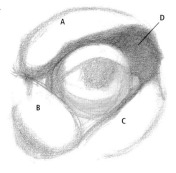

▲ A, B, and C are bulging forms surrounding the eye; D is concave.

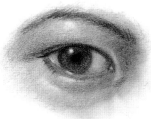

▲ The eye of the Asian race has additional deposits of fat within the eye socket. It also has an extra fold of skin above the inner corner that combines with the upper lid.

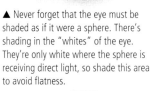

▲ Never forget that the eye must be shaded as if it were a sphere. There's shading in the "whites" of the eye. They're only white where the sphere is receiving direct light, so shade this area to avoid flatness.

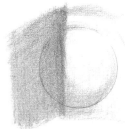

▲ If the entire eye socket is in shadow, then I beg you, please make the "white" of the eye darker.

▲ From this angle, the outer corners of the eyes are lower than the inner corners.

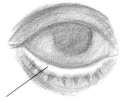

Students always forget this plane. Also, any line where the lower lid meets the eyeball is subtle.

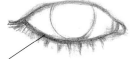

Wrong: A big black line and no plane.

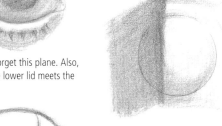

▲ The eye is on the corner of the face.

▲ The eyes are on an arc.

Noses

Step 1 Check the nose's vertical angles and size compared with other features.

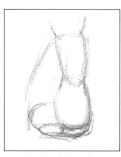

Step 2 Identify the planes and forms of the nose.

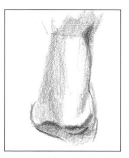

Step 3 Add tone to the nose to represent the core and cast shadows.

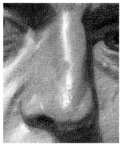

Step 4 Stump and then pull out highlights for a realistic effect.

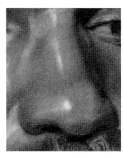
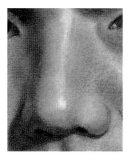
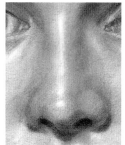
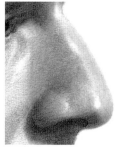

Nose Variations Noses come in a wide variety of shapes. Notice the differences between the noses of a black male (far left), an Asian male (left center), a Caucasian female (right center), and a Caucasian male (far right).

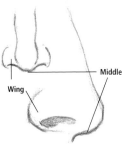

Wing · Middle

▲ The middle of the nose is usually lower than the wings.

▲ Note how changing the angle of the nostril (the opening) affects the character of the nose.

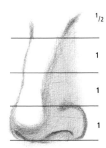

$^1/_2$
1
1
1

▲ The height of the nose is about $3^1/_2$ wings high.

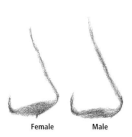

Female Male

Female noses tend to be smaller and tilted upward a bit when compared with a male's.

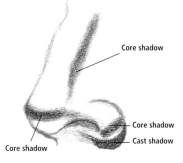

Core shadow
Core shadow
Core shadow
Cast shadow

Remember to delineate the core shadows and the cast shadows.

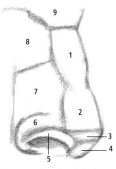

9
8
1
7
2
6
3
4
5

These are the nine typical planes to look for on noses.

Correct **Wrong**

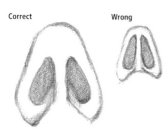

▲ The nostrils don't extend to the tip.

Correct **Wrong**

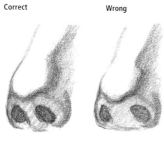

▲ The space between the nostrils is narrow.

Looking down on the nose

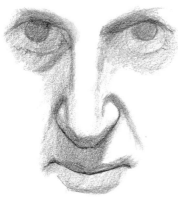

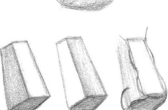

Make simple forms before adding character.

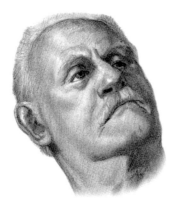

▲ Be ruthless about just how close the tip of the nose is to the eye when your model is looking up! The distance diminishes.

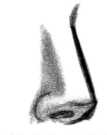

▲ Avoid drawing big, thick, black outlines around the light side of the nose.

Don't forget this little feller. The wing of the nose has a ridge that wraps underneath to the middle of the nose.

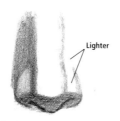

Lighter

Notice that both nostrils can't be the same tone and that one side of the nose must be lighter (with side lighting).

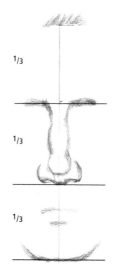

1/3

1/3

1/3

▲ The nose is approximately one-third of the face: one-third chin to nose, one-third nose to brow, one-third brow to hairline.

Correct **Wrong** **Wrong**

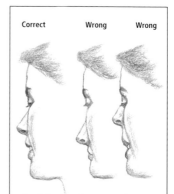

Carefully place the nose at the correct level before developing it. The seven-eighths view (shown above and below) is especially tricky.

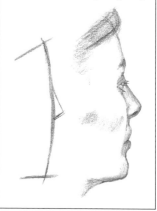

The Mouth

Step 1 Lay in the size, location, and angle of the mouth.

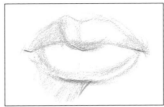

Step 2 Build the volume and add tone for the core and cast shadows.

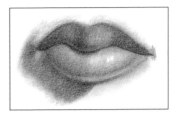

Step 3 Stump and then pull out highlights for a polished look.

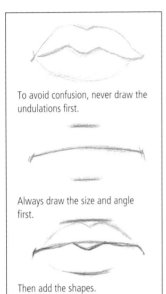

To avoid confusion, never draw the undulations first.

Always draw the size and angle first.

Then add the shapes.

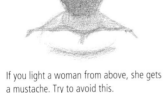

The mouth isn't flat. It's stretched over a cylindrical muzzle.

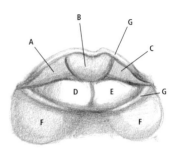

There are three forms for the upper lip (A, B, C); two forms for the lower lips (D, E); and two "pillars" underneath (F). Note the ridges above and below the lips—they often get their own highlights (G).

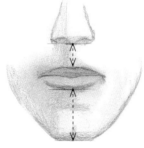

▲ The mouth is usually closer to the nose than it is to the chin.

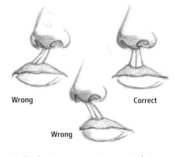

Wrong

Correct

Wrong

▲ Students never want to accept that the middle of the lips is directly below the middle of the nose.

If you light a woman from above, she gets a mustache. Try to avoid this.

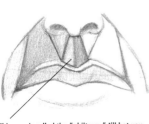

This area is called the "philtrum." I'll bet you didn't know that!

Mouth shown from below

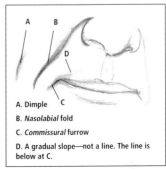

A. Dimple

B. *Nasolabial* fold

C. *Commissural* furrow

D. A gradual slope—not a line. The line is below at C.

20

*"Sargent greater than Ribera?
We're takin' this outside!"*

"You actually want to buy a painting?"

*"This book's gotta be done in one month?
Yikes!"*

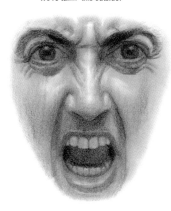 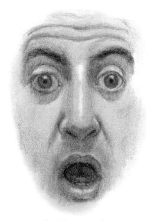 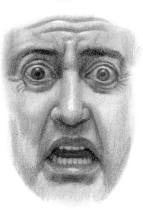

The Mouth and Expression The mouth assumes predictable shapes for the emotions. Note the square for anger, the small circle for surprise, and the trapezoid for fear. The handsome gent in the examples above was drawn with the aid of a mirror—a great tool for checking the veracity of an expression.

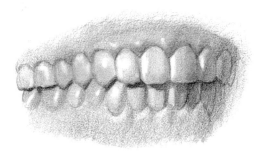

**Every tooth
has a highlight.**

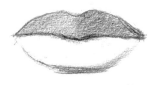

Curve and shade those teeth back, or the teeth will jut forward at the corners, and you'll get a danged toothy grin.

Err on the side of too light when adding lines between teeth.

**It's rare for both sides of the
muzzle to be the same shade.**

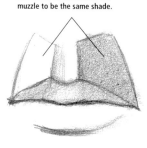

When lit from the side, the lips darken as the forms turn away from the light source. (Notice the sharp-edged shadow cast from the upper lip onto the lower lip on the shadowed side.)

Because the top lip faces down and the bottom lip faces up, they're rarely the same shade.

**These three planes
are usually in shadow.**

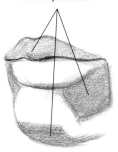

▶ Portraitists often get lazy with the lips. It breaks my heart. You must accentuate the details. Look at the reflected light on the corners of the upper lip. The reflected light tends to show up under the core shadow, and the line between the lips isn't a line—it's a cast shadow.

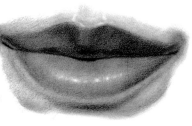

Hair

Don't think of hair as a series of lines or squiggles—instead, treat it as a mass with texture. Following the steps and tips below will help you draw it realistically.

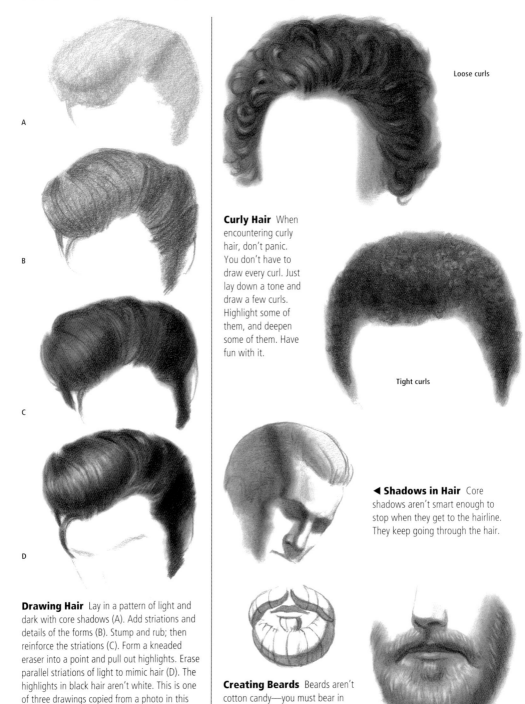

Loose curls

Curly Hair When encountering curly hair, don't panic. You don't have to draw every curl. Just lay down a tone and draw a few curls. Highlight some of them, and deepen some of them. Have fun with it.

Tight curls

◄ **Shadows in Hair** Core shadows aren't smart enough to stop when they get to the hairline. They keep going through the hair.

A

B

C

D

Drawing Hair Lay in a pattern of light and dark with core shadows (A). Add striations and details of the forms (B). Stump and rub; then reinforce the striations (C). Form a kneaded eraser into a point and pull out highlights. Erase parallel striations of light to mimic hair (D). The highlights in black hair aren't white. This is one of three drawings copied from a photo in this book. It's a picture of my father's hair. Mom says he was a famous singer in the '50s.

Creating Beards Beards aren't cotton candy—you must bear in mind a structure as you render the volumes.

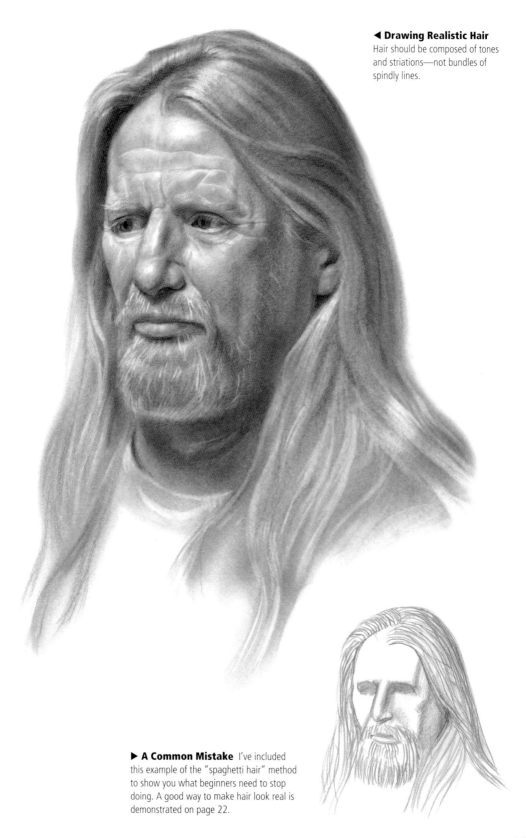

◄ **Drawing Realistic Hair**
Hair should be composed of tones
and striations—not bundles of
spindly lines.

► **A Common Mistake** I've included
this example of the "spaghetti hair" method
to show you what beginners need to stop
doing. A good way to make hair look real is
demonstrated on page 22.

EXPRESSIONS

For this section on facial expressions, I drew the models from life and coaxed them into specific expressions. I must recommend, however, that you use a camera to capture fleeting expressions. A photo can be copied on its own or—ideally—used in combination with sessions with the live model.

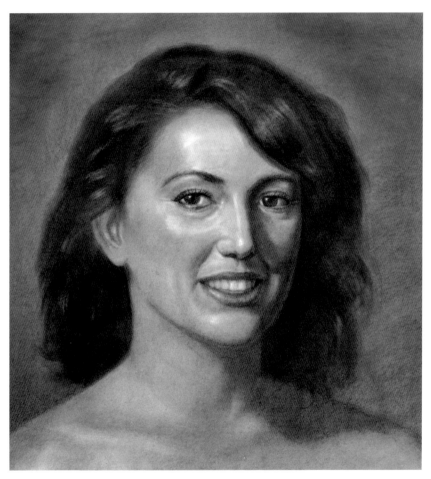

Broad Smile Regardless of how you work, an artist is expected to know a few rules of how to achieve his or her purpose and not arrive at "accidental" moods. Below is a list of important changes that you must check when drawing a broad smile. As you work, remember that the lines at the corners of the mouth shift and sometimes disappear. See the cover drawing or the *Mona Lisa!*

A. The areas above and below the mouth become shallower as the lips widen.

B. Lips stretch and fold in at the sides, which leaves more light in the middle.

C. The cheeks bulge up and should have a highlight indicating this.

D. The upper eyelids lower slightly, but the lower eyelids rise, covering the bottoms of the irises. This is essential to depict.

E. Laugh lines form around the eyes and mouth. It's tempting to minimize these to flatter the model, but don't. Without the appropriate wrinkles and folds, your drawing will not look correct.

F. Be very selective about when to show lower teeth. They're barely visible unless the expression is very intense.

G. The nostril wings widen and rise.

H. The eyebrows remain relaxed.

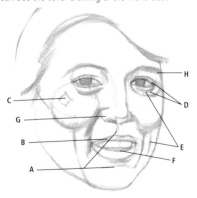

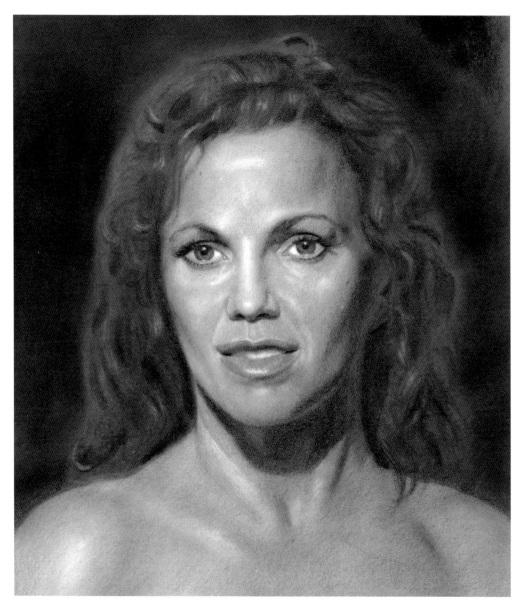

▲ Gentle Smile Here I depict a hint of a smile that one might have in mid conversation. Items A through H from page 24 are repeated here, but only subtly. I can keep a woman smiling until she realizes she despises me, but if you can't, try the following strategy. Ask the model to smile for 30 seconds and quickly check an item from my list. Then let her relax for 5 minutes and ask again. Notice how the lines between the teeth are drawn as lightly as possible. Also, the teeth are shaded as they turn away from the light. If you forget this, they will appear to jut forward and out at the sides of the mouth.

▶ Indicators of a Gentle Smile This diagram shows important areas involved in a gentle smile. A slight covering of the bottom of the iris will help create the smile (A). Careful—if you raise the *nasolabial* fold too much at the nostril, the model will have a sneer (B). The positions of highlights C and D depend on the intensity of the smile. Notice that the highlight on the forehead (E) is brighter than the one on her chin (F).

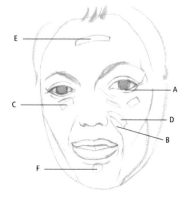

Expressions to Avoid

Although the emotions depicted in both of the following drawings are intentional, students tend to create them accidentally. These examples will help you understand what to look for in an expression and how to improve on it to create a portrait with the expression you intended.

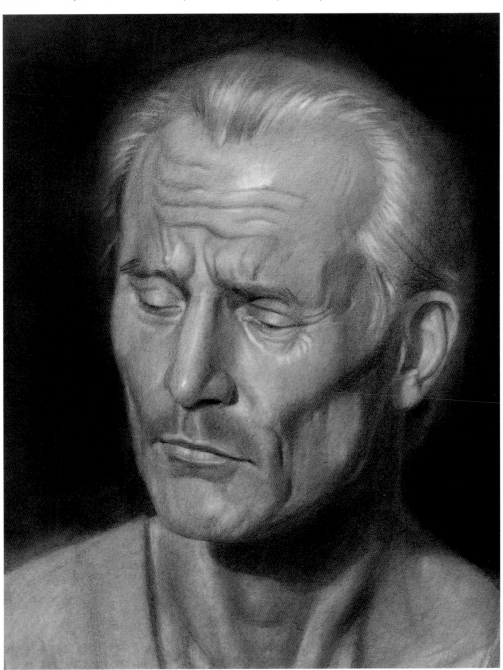

Sad or Concerned Expression Robert's eyebrows are pulled down but are raised in the center, and his forehead is wrinkled, suggesting sadness. It's amazing how often I have to tell students to lower the brows in the center to relax the expression. I've also given Robert a slight pout by pushing up the lower lip and compressing the forms around the mouth. The work around the mouth is just barely noticeable.

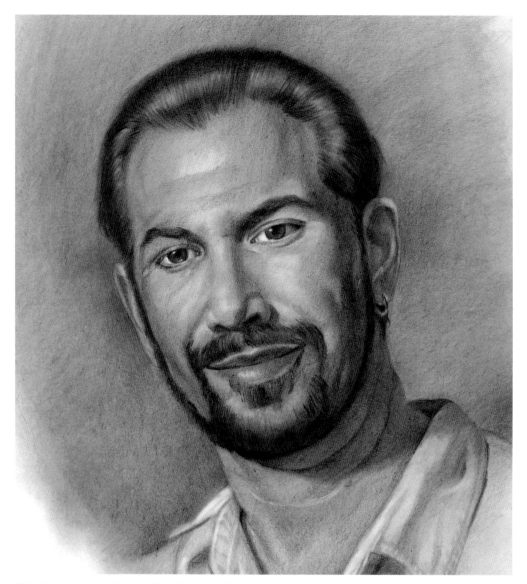

Mischievous Expression Daniel's smile is nice and sincere, but his brows are lower in the center than the average person's, giving him a mischievous look. If you see this type of expression in your drawing but not on your model, consider lifting the brows a bit at the center.

▶ **Considering Design** By subtly repeating a shape in your drawing, the portrait will become more cohesive and rhythmic. I discovered several natural curves on Daniel (including the lines around the neck, the shape of the beard, the earring, etc.), so I began adding and emphasizing them. Some drawings will suggest squares or triangles instead. Emphasizing a shape and repeating it may seem silly, but it's actually a technique used by the old masters.

PROJECT 1: MAN

We now begin the step-by-step method for drawing. I have done four projects—an adult male, an adult female, a young girl, and a young boy. Each of these projects is broken down into what I consider the seven stages of drawing: the lay-in, plumb lines, volume, edges and outlines, tonal pattern, finishing, and polishing. The first project provides the most detail on these seven stages, so it's best to start here. However, I urge you to read all four projects because I include slightly different information in each. Actually copying the stages (drawing each step over the previous) would be commendable. (Note that all projects call for the 9B pencil, only switching to 5B or 2B for small details.)

STAGE 1

The Lay-In Because the lay-in and the next step, plumb lines, seem so basic (and ugly), artists usually rush through them. But these steps ensure the success of the drawing. You can always adjust your shading, but if sloppy work now leads to bad proportions, then the drawing will require major surgery later. The first measurements must be exact to achieve a likeness.

1. Draw an oval; then add a vertical arc (A) that follows the curvature of the model's face. Place horizontal marks at the top, bottom, and midpoint (B) of the oval. Next determine the midpoint of the model's face by extending your arm—elbow locked—and placing the tip of the pencil where you imagine the center to be and placing your thumbnail in line with the model's chin (see diagram below).

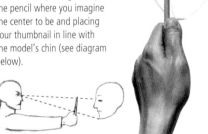

2. Now raise your arm so that your thumbnail is where the tip of the pencil was. If the tip is now at the top of the model's head, then you've found the center. If not, simply keep adjusting the pencil and your thumb, repeating steps 1 and 2 until your nail and the tip consistently fall halfway up the model's face (the midpoint).

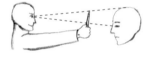

*NOTE: If this is a private session and you're working at life-size, you should actually measure the distance from the inner corner of the model's eyebrow to the bottom of his chin with a ruler and place this measurement on your paper. It's not the center, but it's very accurate. Don't poke him in the eye with the ruler.

3. Note the form that you found at the midpoint of the face (for example, the tear ducts). Then use this to guesstimate the distances of other features from top to bottom, including hairline to browridge, eyes to bottom of nose, lips to chin, top to browridge, nose to chin, and so on. Don't measure these with the pencil because the forms are so small that it's easy to make a mistake. If you put the drawing next to the model, it may be obvious what the distances should be.

Make sure these horizontals are placed along the vertical arc so you can establish the center of the face. Draw lightly—these guidelines are for you, not for art history. Also, remember basic proportions of the head: hairline to brow is roughly one-third of the head's length, brow to bottom of nose is roughly one-third, and bottom of nose to bottom of chin is roughly one-third.

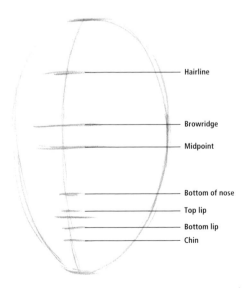

Hairline

Browridge

Midpoint

Bottom of nose

Top lip

Bottom lip

Chin

*NOTE: All hands in this book used to show measurement are drawings.

STAGE 2

Plumb Lines Now that we have the proportions roughly laid out from top to bottom, we can work on the widths. Always work out the vertical measurements first because it's easy to narrow a form but big trouble to lengthen one (in this case, everything has to move).

1. In this step, you'll use your eyes to guesstimate a rough shape that would fit between the marks you measured in stage 1. This will not be a precise outline. We just want a shape that has the basic width and size of the model's features. To do this, first mark a width for each feature that corresponds to the marks you made for the lay-in (A). Then compare general sizes: How much space does the nose occupy on the face? Which takes up more space—the lips or one eye? Compare back and forth between the features. Then begin to suggest the basic shape of each feature (B).

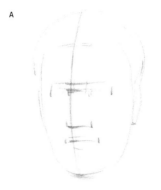
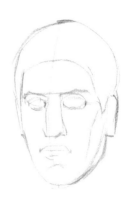

2. You now must use plumb lines to make sure the forms are aligned properly above and below one another. Wouldn't it be helpful to know if the tear ducts are directly above the nostrils? Does the side of the neck line up directly below the corner of the mouth? Put your pencil in front of the model's face vertically and check (A). Then place the pencil horizontally to gauge the alignments, including earlobe to nose, mouth to corner of jaw, and so on (B). Adjust the drawing accordingly.

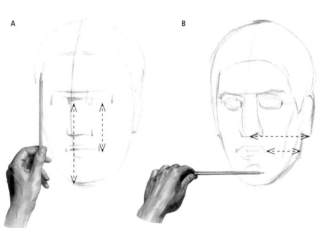

3. Pay attention to *negative space* (the space between the forms). If you ignore it, you won't achieve a likeness and may never figure out why. The space between the forms is as important as the forms themselves. Continue checking these distances as you draw.

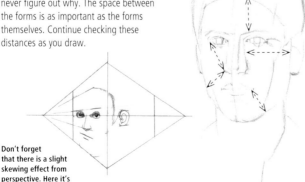

Don't forget that there is a slight skewing effect from perspective. Here it's exaggerated to make a point.

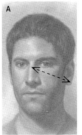

Always compare the two key measurements above. Hold your pencil out and have your thumbnail touch the bridge of the nose while the tip touches the ear (A). Now turn the pencil and see how this length compares with the same point on the nose to the chin (B).

STAGE 3

Volumes Michelangelo either imagined or faintly drew volumes before he began shading. At this stage in the drawing, we will follow him. It's true that he uses obvious outlines in his drawing, but I think he did this to make the drawing hyper clear so he could easily refer to it to create a mural (the final painting on the Sistine Chapel). Be sure to keep your outlines much lighter as you draw.

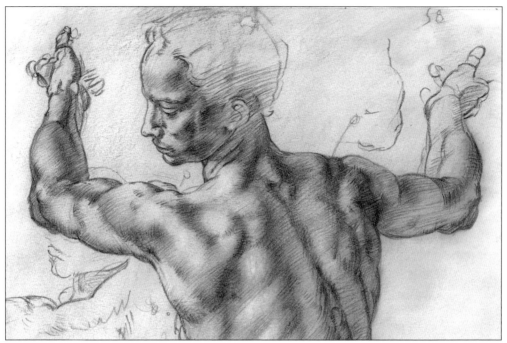

My study for the *Libyan Sibyl* on the Sistine Chapel (after Michelangelo)

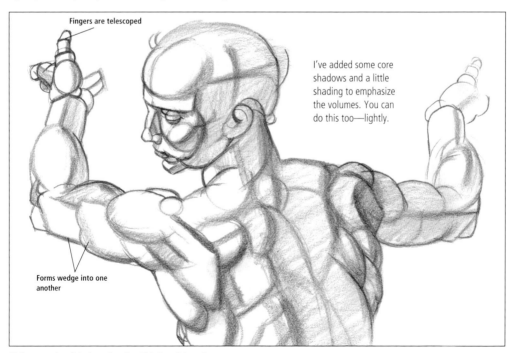

Fingers are telescoped

I've added some core shadows and a little shading to emphasize the volumes. You can do this too—lightly.

Forms wedge into one another

My interpretation of the forms based on Michelangelo's work

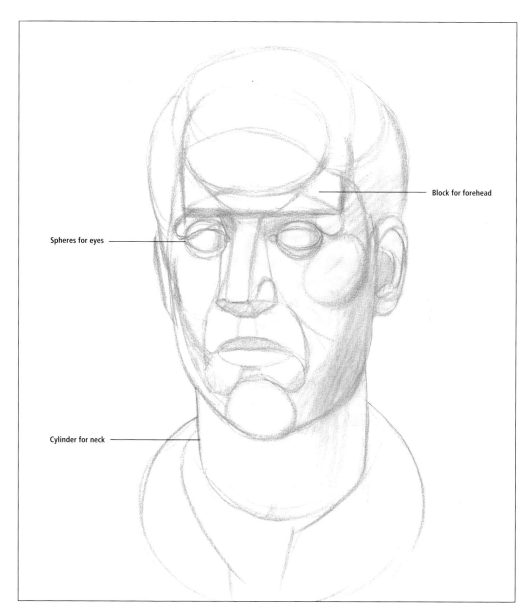

Block for forehead

Spheres for eyes

Cylinder for neck

STAGE 3

Volumes (continued) With an accurate lay-in on the paper, there's no chance of making a huge mistake, so you can relax and develop the structure on top of the plan. Faintly draw a simple volume that might protrude beneath the surface of each form. Beginners sometimes resist this practice, as I first did. But when I finally began drawing them, my drawings immediately had more structure and a greater sense of three-dimensionality. Understand that the artist isn't making anything up. If the model were hollow, the volumes could fit inside the skin; but they are obscured by the surface of the skin. Therefore, you will shade over the volumes, erase them, and leave them, depending on what makes the drawing look more real. But having them there initially gives you a guide—a framework upon which to add details and lighting. You can't be distracted by the surface because the volumes remind you of the mass underneath. If you look at the portraits of late Titian, late Rembrandt, and Pontormo, you'll see that the heads could be reduced to spheres hovering in space. The great realist always draws the big mass, integrating smaller masses into it. The way to do this is to draw a large shape—an egg or a cube for the head—and then spheres and blocks on top of it. The shapes of these forms are *your* choice, as they're suggested to you by the model's appearance.

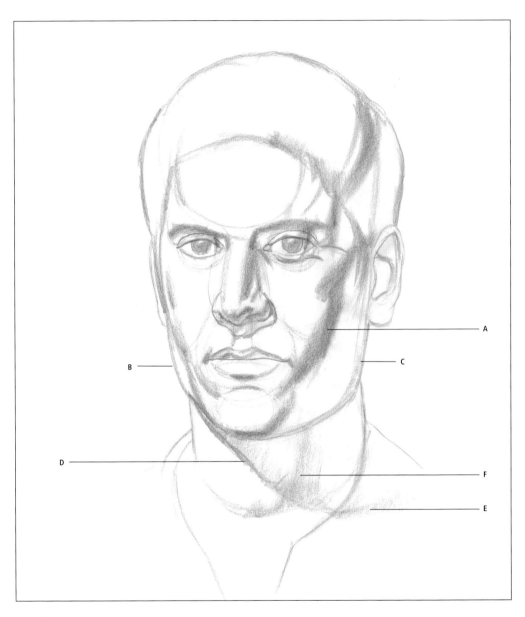

STAGE 4

Edges and Outlines Using the volumes as guides, draw the outlines and the core shadows. The core shadows are on the edges of the shadows (A). Amateurs leave out core shadows because they don't notice them, but core shadows give the forms corners and, hence, a three-dimensional quality. Core shadows are darker parts of the shadows, and they're always soft. Don't draw them as sharp lines. Please don't. Just don't, okay? When they happen to be darker than the outline, the form really protrudes.

When drawing the outline, try to draw one side of the form (B) and then the other (C). You can do this with the jaw, cheekbones, nostrils, and so on. Sometimes, as on this nose, you must outline one side, then turn your pencil to the side and shade the core shadow. Keep the outline faint—it is not a thick, black stroke. In some places, it fades away entirely, and by the end of the drawing you should have shaded up to it so that it no longer appears as a line. So don't grind it in now. But you must have a clear point where the form stops, so an outline must be there.

You must also draw the edges of the cast shadow (D). The edges aren't razor sharp, but they must be very clear—especially compared with the softness of the core. The shadow's edge will soften and lighten as it travels away from the form casting it (E). The shadow edge on the form is core (F); the edge thrown by the form is cast. Note your model's softest and sharpest shadow edges.

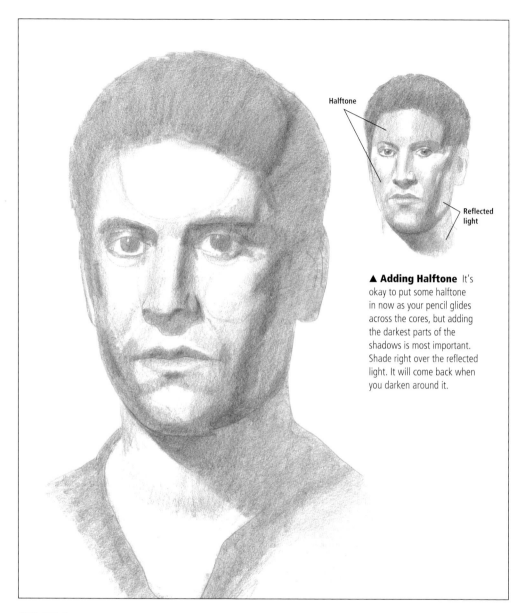

Halftone

Reflected light

▲ **Adding Halftone** It's okay to put some halftone in now as your pencil glides across the cores, but adding the darkest parts of the shadows is most important. Shade right over the reflected light. It will come back when you darken around it.

STAGE 5

Tonal Pattern This should be the simplest stage. It's actually better if you think very little during this stage. Just squint your eyes, and the model's face will become blurry and simplify into a pattern of dark and light. If you squint hard enough, the halftones in the light area and the reflected lights in the dark area will no longer distract you. The brain wants to exaggerate every tone (to show how clever it is), but if you draw only what the eye sees, your drawing will be more accurate. Great portraitist Velázquez always subordinated detail into the overall pattern. Without any "finish," he painted accurate tones that look very realistic from a distance. To judge tone correctly, you must squint often. This fresher eye will tell you when an area has fooled you into inaccuracy. Correct tone is the mark of a master realist.

If the model has a lot of shadow on his face, you can experiment with drawing this tonal pattern at earlier stages (though never before the lay-in and plumb line stages). Personally, I find that a little toning is valuable to judge proportions and decide where to outline.

Try to shade in one direction for the whole head (along or across the cores). Fill in gaps and shade evenly. This pattern initially will be of medium darkness. Shade over several forms with the same strokes (e.g., face through hair through ear).

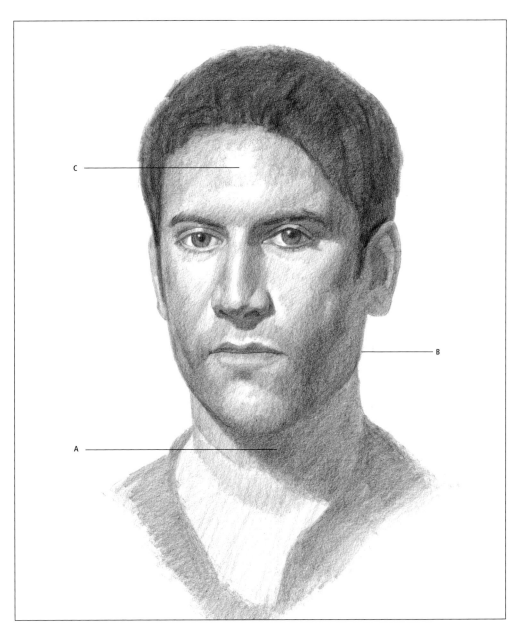

STAGE 6

Finishing I recommend always drawing with a kneaded eraser in your opposite hand so you can continually clean up mistakes as you go along. Moreover, you've now had five stages to achieve accuracy of outlines and proportions. Between the erasing and constant checking, the drawing should be extremely accurate.

Now you need to concern yourself only with adding correct tone (value). This consists of adding darks and halftones. The darks must be gradually blended into the halftones by repeatedly caressing the side of the 9B into the "bed" of tone (A). Darks must be shaded up to any lines either on the outline or on the edges of the cast shadows (B). Lines must be hunted down and eliminated like vermin. They are the enemy of realism and must suffer accordingly. Eliminate them by shading up to them. Caress halftones from the outlines or the core shadows all the way up to the highlights (C). Feckless students shade over the highlights, hoping to erase them out, but this will result in flatness. By stopping at the highlight, a clear plane change emerges. Later you can, and should, rub over and erase them out, but first you must establish a clear division between the highlight plane and the halftone plane to avoid the charge of vagueness, which is so common in our drawing and in our times!

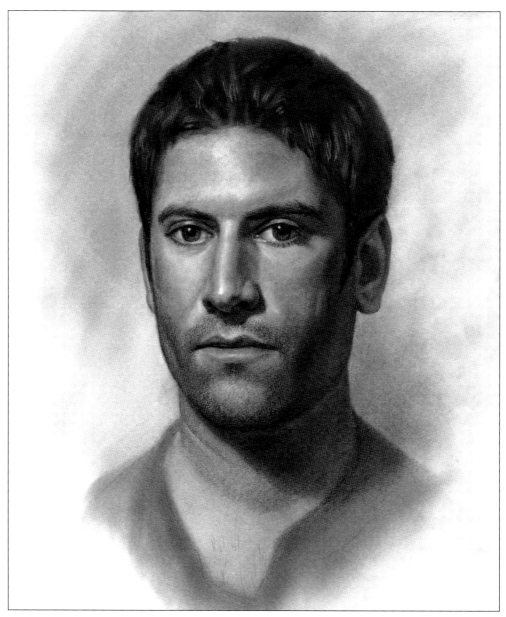

STAGE 7

Polishing This stage will be time consuming and can be messy. Refer to the "egg rule" on page 53. As you stump, rub, and highlight, note that the head gradually darkens as it turns away from the highlight. Any deviation in tone will look like a bruise. Your blends must transition smoothly. Don't leave patches of light or dark. Begin by using your stumps to rub the core shadows. Remember to stump *with* the core—hatching across it just creates patches. Use the "cone" of the stump, not the tip—the tip also creates patches. Use the tip in small areas. At this point, it's okay to grind in the Staedtler® 8B for extreme darks. Put an object that's truly black up to the model so you can see how dark to go. Rub most of the drawing with the powder puff. You can also go in with the make-up applicator in place of the stump—experiment to see which tool works best for different areas. This smearing may change the tones, forcing you to reevaluate them. At stages like this, you may have to flatten your kneaded eraser and press it onto areas to lighten, but not erase, them. Pull out highlights with your mechanical and battery erasers. Finally, drag a 9B over the chin and leave it rough to create stubble. Project 1 is now complete!

PROJECT 2: WOMAN

STAGE 1

The Lay-In 1. First draw an oval with a 9B pencil. The straight-on view calls for a somewhat symmetrical shape, but don't worry about making the shape of the head accurate at this point; the oval simply is a tool to establish the size of the head. Mark the midpoint of the oval. Now you must find the midpoint on your model so you can place reference marks for nearby features, such as the eyes and browridge. To do this, hold your pencil vertically with the pencil tip up. Extend your arm with your elbow locked, and place the pencil tip where you estimate the midpoint to be.

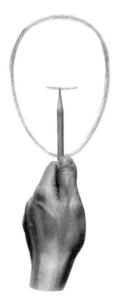

2. Then move your thumb along the pencil until the top of your thumbnail is in line with the model's chin. Now check yourself: Raise your arm so that the top of your thumbnail is at the estimated center. If the tip is now in line with the top of the model's head, then you've found the midpoint.

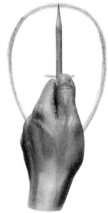

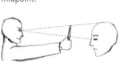

3. Now add a line to establish the vertical center of the oval; then estimate and check other vertical distances, marking the bottom, top, and center of the lips; the tip and base of the nose; the browridge; and the hairline.

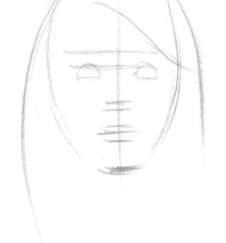

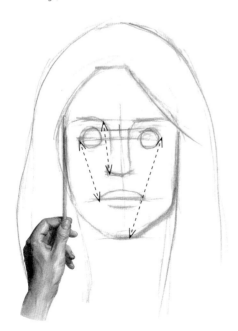

STAGE 2

Plumb Lines During this stage, you'll nail down the placement of the facial features by checking your verticals, horizontals, and negative space. Begin by marking an estimated width for each horizontal line along the vertical line; then roughly block in the features. Compare the sizes of the features with one another, and continue to check the horizontal and vertical plumb lines, adjusting your drawing as necessary. As you draw, remember that the negative space between the forms is as important as the forms themselves, so compare the spaces in your drawing with your model often. As you check the verticals and horizontals, assess the negative space (as shown by the arrows), which will help you find any shapes that might differ from those of your model.

STAGE 3

Volumes With all the measuring complete, you're now free to draw more intuitively. Try imagining simple forms that would fit inside the face under the surface that you see. The forms will help guide you—although the forms may look robotic, the human quality will emerge as you refine their shapes and tones. Using an underhand grip (hold the pencil with your hand over it, with the pencil between the thumb and index finger) for loose, light strokes, start with the largest forms and draw the smaller ones into them. Represent the forms with basic volumes—spheres for eyes, eggs for cheekbones, and so on. Imagine that you are overlapping transparent forms, building up from larger to smaller forms. This stage should take only a few minutes. The forms I chose don't have to be your forms. Also, every model is different and suggests a different set of volumes.

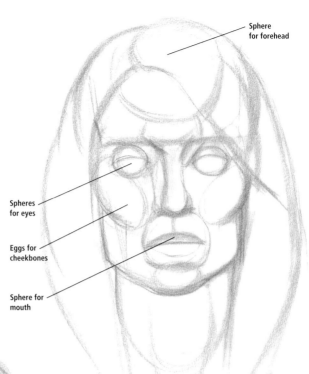

Sphere
for forehead

Spheres
for eyes

Eggs for
cheekbones

Sphere for
mouth

STAGE 4

Tonal Pattern This stage can come after stage 5, depending on what works best for you. If you think you're at the point at which you can create an accurate outline, skip ahead to stage 5 and then return to this stage. However, I find that first establishing a shadow pattern sometimes helps me find where to place the outline. To begin this stage, look at your model and squint your eyes to see the face as a pattern of light and dark. The extreme highlights and darkest accents will blend into the main pattern. Now begin blocking in this pattern of tones on your paper, turning your pencil to the side and shading diagonally for quick coverage. Keep your strokes close together, and shade all the dark areas in the same direction to keep the drawing from appearing chaotic. (However, in more developed stages, one may shade in different directions when adding core shadows and dark accents.)

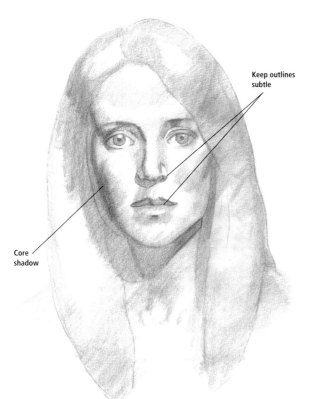

Keep outlines subtle

Core shadow

STAGE 5

Edges and Outlines Every form on this model's face has a side plane, front plane, and sometimes a clear bottom plane. The softened corner where the planes meet is the core shadow. Turn your pencil to the side and shade a thick bar of tone—not a line—from her hair to her temple, around her cheekbone, and all the way to her chin. The core shadows overlap and soften where the forms soften. Don't ignore core shadows on the sides of the eyes or tip of the nose. As you add the core shadows, also add the subtle outlines. The outlines work like a parenthesis for each form. Try to outline one side of the form, then the other; then add the core and go back to the sides again—all in one operation. Now sharpen the edges of the cast shadows, keeping them sharpest where they are closest to the forms casting them.

STAGE 6

Finishing Now work within the new outlines to continue developing your shading. Caress your pencil over the core shadows to pull halftone across them, diminishing the tone as it reaches the highlight. Notice how the halftones softly and gradually emerge from the core. They aren't isolated islands of tone; they mass against the core. As you shade, squint your eyes often to compare the relationships of tone on the model with those of your drawing. To make sure you're shading thoroughly, try holding a piece of white paper up to the model's face. With the exception of a few small white highlights, the entire face should have tone. Now switch to a harder pencil, such as a 5B or 2B, and develop and darken details on the face.

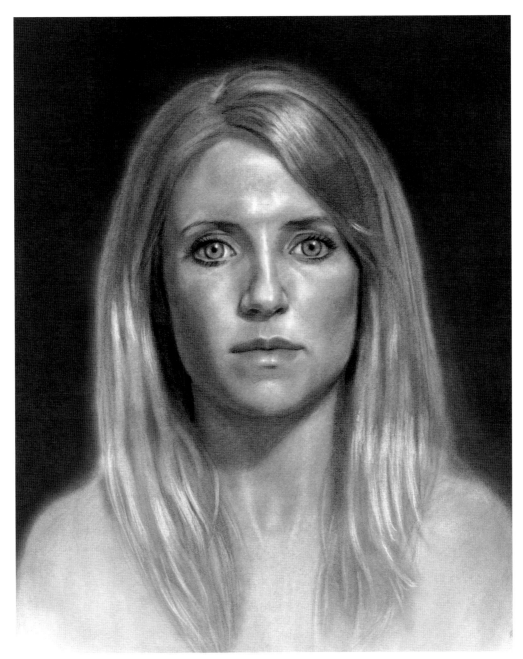

Elizabeth T. Gilbert, one day, life-size

STAGE 7

Polishing This is the longest stage; within it, the previous stages usually have to be repeated to some degree. Begin stumping the core shadows, and rub a make-up applicator over the dark details to soften and blend them. Burnish the entire drawing by caressing it with a powder puff, and then pull out the highlights with your kneaded eraser. If the highlights are too sharp, soften the edges with a clean stump. If the highlights won't easily erase, a battery-operated eraser should do the trick. After burnishing, your drawing may lose a bit of value. In this case, simply go back in and re-introduce the darkest darks of the face. I chose black for this model's background because it creates a wonderful contrast with her blond hair. (To determine the best value for the background, it often helps to place a white, gray, or black sheet of paper behind the model, which allows you to see the different balances of tones.) To create a dark background quickly, dump out a pile of graphite powder and use your powder puff to rub it across the paper, repeating if necessary. (Remember that faces are never perfectly symmetrical; for example, your model's nose may veer slightly to one side.)

PROJECT 3: YOUNG GIRL

STAGE 1

The Lay-In The tricky part about drawing a nine-year-old from life is getting the little beast to sit still. I propped Celeste in front of a TV and drew her, life-size, in two sessions of two-and-a-half hours. Sometimes a child can be transfixed by video games, motionless as Mount Rushmore. I believe God will forgive us if we use photos for children. But try to adjust the halftones from life.

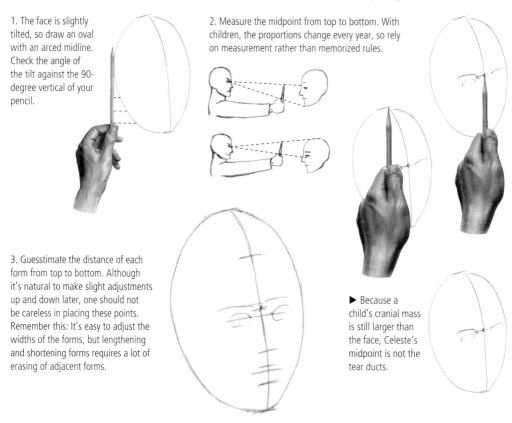

1. The face is slightly tilted, so draw an oval with an arced midline. Check the angle of the tilt against the 90-degree vertical of your pencil.

2. Measure the midpoint from top to bottom. With children, the proportions change every year, so rely on measurement rather than memorized rules.

3. Guesstimate the distance of each form from top to bottom. Although it's natural to make slight adjustments up and down later, one should not be careless in placing these points. Remember this: It's easy to adjust the widths of the forms, but lengthening and shortening forms requires a lot of erasing of adjacent forms.

▶ Because a child's cranial mass is still larger than the face, Celeste's midpoint is not the tear ducts.

STAGE 2

Plumb Lines Now indicate the width of the head and check the horizontals. It's easiest to judge a tilted angle by placing a true horizontal below it (A). Next check the verticals and adjust as necessary (B); then check the spaces between the features (C).

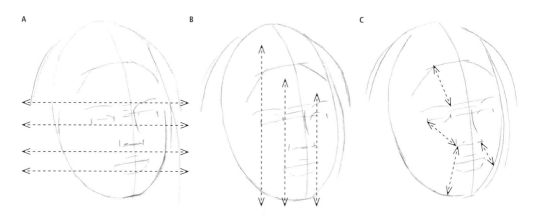

A B C

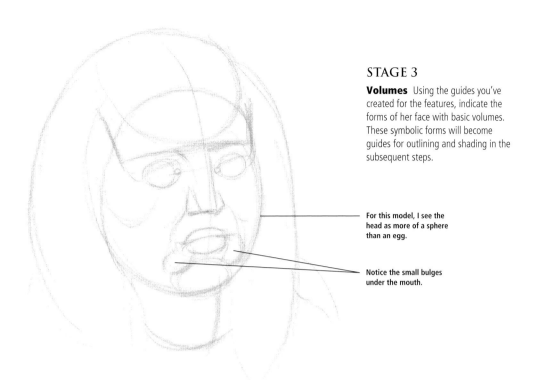

STAGE 3

Volumes Using the guides you've created for the features, indicate the forms of her face with basic volumes. These symbolic forms will become guides for outlining and shading in the subsequent steps.

For this model, I see the head as more of a sphere than an egg.

Notice the small bulges under the mouth.

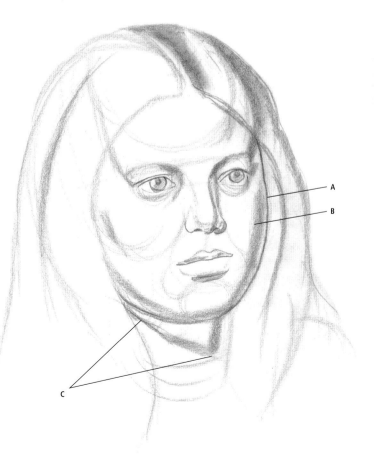

STAGE 4

Edges and Outlines With this particular head, it's better to find the outlines before filling in the tonal pattern. Use soft outlines in most areas, but note that the outline can be dark if bordering a dark area (A). (Remember not to grind in the pencil until stage 5.) Now draw the core shadows with soft edges so they easily will transition to the halftone (B). If the cores are drawn sharply, you'll have to work very hard to achieve a gradual turn of the form. Remember that cast shadow edges always start sharply and end softly (C).

A

B

C

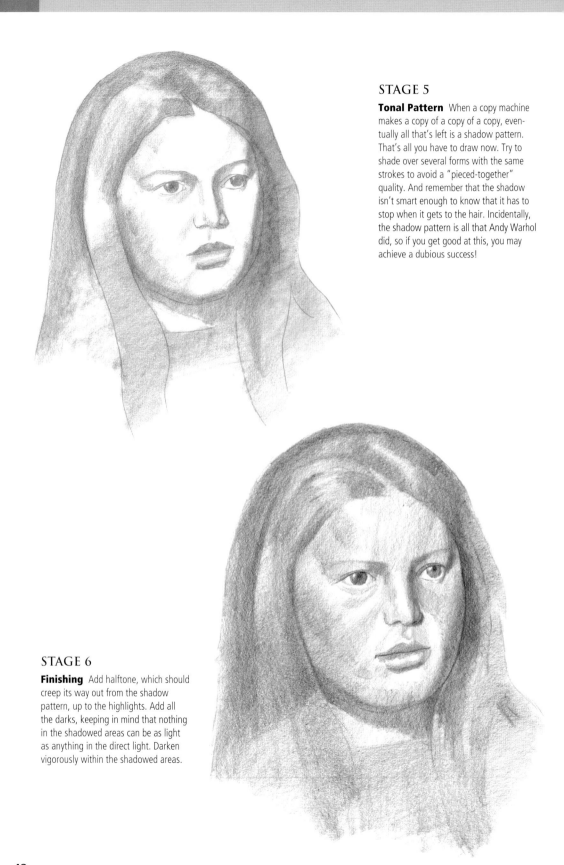

STAGE 5

Tonal Pattern When a copy machine makes a copy of a copy of a copy, eventually all that's left is a shadow pattern. That's all you have to draw now. Try to shade over several forms with the same strokes to avoid a "pieced-together" quality. And remember that the shadow isn't smart enough to know that it has to stop when it gets to the hair. Incidentally, the shadow pattern is all that Andy Warhol did, so if you get good at this, you may achieve a dubious success!

STAGE 6

Finishing Add halftone, which should creep its way out from the shadow pattern, up to the highlights. Add all the darks, keeping in mind that nothing in the shadowed areas can be as light as anything in the direct light. Darken vigorously within the shadowed areas.

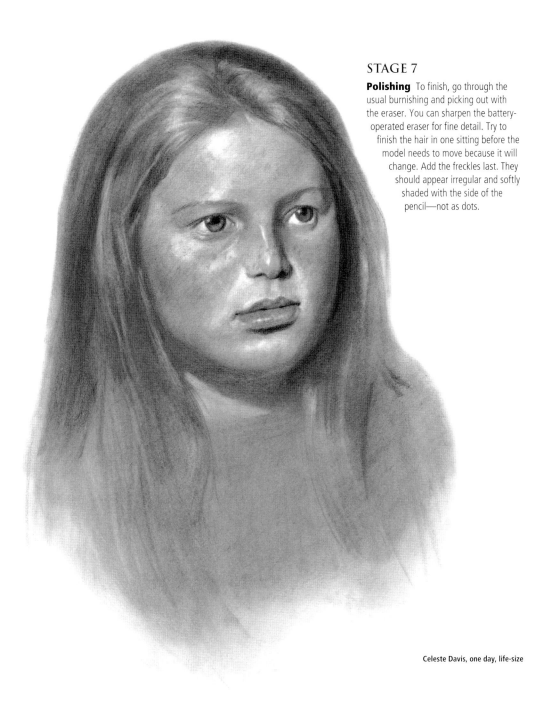

STAGE 7

Polishing To finish, go through the usual burnishing and picking out with the eraser. You can sharpen the battery-operated eraser for fine detail. Try to finish the hair in one sitting before the model needs to move because it will change. Add the freckles last. They should appear irregular and softly shaded with the side of the pencil—not as dots.

Celeste Davis, one day, life-size

Altering the Expression

People love happy children, so I waited until the end of the drawing session to make the appropriate adjustments to Celeste's expression. But just at that point on TV, a unicorn died! So I settled for a true expression, not a happy one. If I wanted to make her look happy, I could gently arc the lips upward, raise the lower eyelids, and relax the inner corners of the eyebrows. A slight bulge in the cheeks might be called for at the nasolabial *fold (the lines that run from the nostrils to the corners of the mouth) and above the cheekbone.*

PROJECT 4: YOUNG BOY

Very often in a portraitist's career, he or she is forced to use photos exclusively. Sometimes it makes everyone's life easier, and sometimes there's simply no choice. For example, I've quite often been presented with an old, weathered, blurry photo of someone who has died. I find that my knowledge of the head allows me to greatly improve on the photo. Regardless of why you may need to work from photos, you should trace them instead of copying them freehand. The client has sent you a reference, and you might as well give them back the exact outlines they've given you. Any creative alterations can come after the photo has been traced.

▶ **Selecting a Reference** I always choose a good photo that the client has approved (then it's the client's fault if he or she doesn't like it). There's a saying commercial artists have about bad references: "Garbage goes in, garbage comes out."

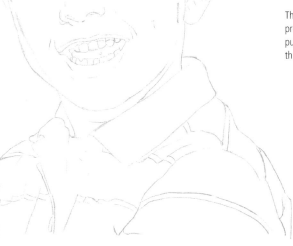

STAGE 1

Transferring Outlines Begin by making black-and-white photocopies of the reference that are a bit lighter than the actual photo, which helps avoid losing detail in the dark areas. The copy can, of course, be a bigger or smaller size than the photo. Using artist's tape (A), secure the photocopy to a piece of graphite transfer paper (B); then place this over your drawing paper (C). Tape only at the top so you can lift the transfer paper to see how it's turning out as you draw. Then trace the important outlines over the copy using a colored pencil, which makes it easy to see where you've been (D). The lines then transfer to the drawing paper (E).

This process seems more practical than using a projector. You also can tape the copy to a window, put your paper over it, and trace. The sun coming through the window creates a free lightbox.

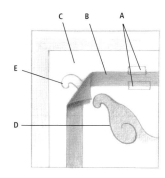

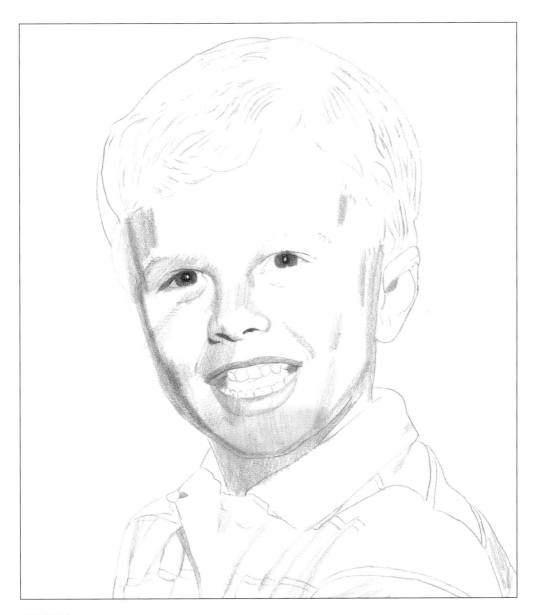

STAGE 2

Adding Darks With a traced photo, no guidelines are necessary. Therefore, you won't need measurements, plumb lines, or volumes. Go right to the shading. In fact, there's no reason to hold back on the darks because you shouldn't have to erase them. To mimic typical commissions, I copy the photo at 8" by 10" so it's smaller than life. At this size, it's necessary to use a harder range of pencils than I do anywhere else in the book: 2B, H, and 2H. These pencils produce fine, precise lines that are perfect for drawing teeth and eyelashes at this size.

A Word of Encouragement

During every project, there's a moment when I feel like quitting because it seems impossible to complete the task, and because I think that maybe I don't have the talent. Experience has taught me to ignore this anxiety, compose myself, and simply put in more time and effort. This solves the problem. My friend Pete de Freitas of the rock band Echo and the Bunnymen told me that if a song isn't right, it simply needs more work. I was surprised to hear this about music.

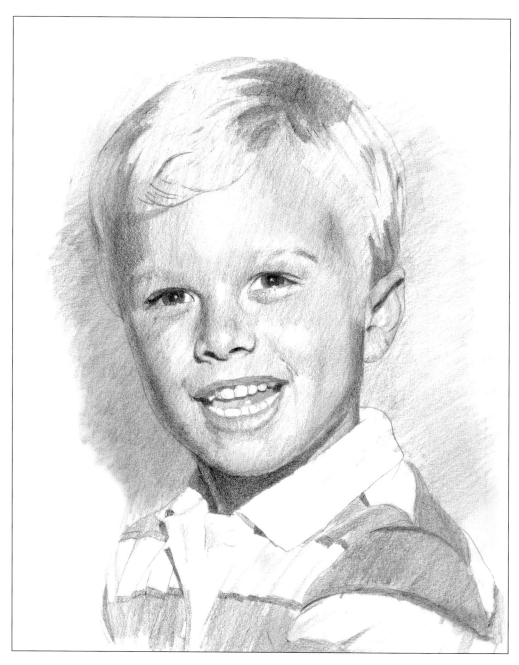

STAGE 3

Building Tone Now develop the forms using tone and detail. To prepare for the final look of polished realism, you need to have the shaded areas in their final locations. The surface must have enough graphite for you to begin stumping and blending in the next stage.

Addressing Mistakes

For me, the most frustrating thing is seeing a student erase an entire drawing and start over. By doing this, he or she makes the drawing 100 percent wrong, whereas before he or she may only have been 15 percent wrong here and there. So, instead of erasing, I resolve to stump, darken, and generally "mother" each form until it has a convincing three-dimensional quality.

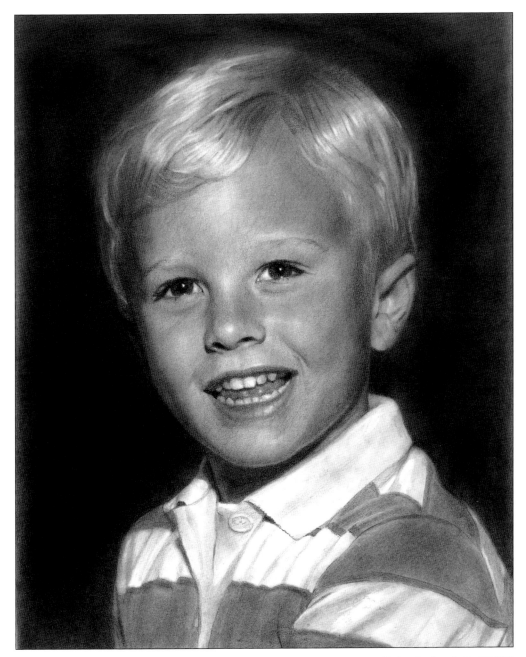

One long day, drawn from a photograph

STAGE 4

Finishing and Polishing My drawings have polish because I polish them. To go from the previous step to this one, reach for the powder puff, the stump, and the make-up applicator. Don't just rub the whole thing. It's good to start by stumping the shadows, darkening them and dragging the graphite across the forms. Then rub the powder puff everywhere, and pull out the lights and highlights with a kneaded eraser. Be careful to soften the edges of the highlights so they don't look like lightning bolts. Repeat all of these steps until you're happy. Blacken the background with Design® Ebony Sketching Pencil (Matte Jet Black) powder and the puff. You could go darker by grinding in a Staedtler® 8B pencil, but this may not be necessary. Note that I always alter my reference photos in some way because they're never perfect; in this case, the only thing I did was lighten the stripes of the shirt so they wouldn't compete with the face.

IMPROVING YOUR WORK

Because I can't be with you in person, I've included this section to show you how to correct yourself. In my 25 years of teaching, I've seen four basic categories of mistakes that prevent a drawing from appearing realistic: negative space inaccuracies, overmodeling, outline issues, and tonal problems. This section will show four versions of our model Karolina (drawn accurately below), demonstrating each mistake. Refer to the accurate drawing below as you examine the mistakes on the following pages.

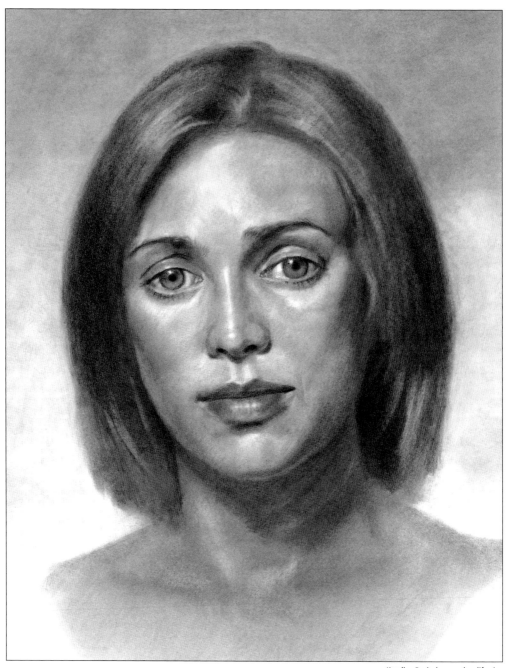

Karolina Rosinska, one day, life-size

The Four Perils of Karolina

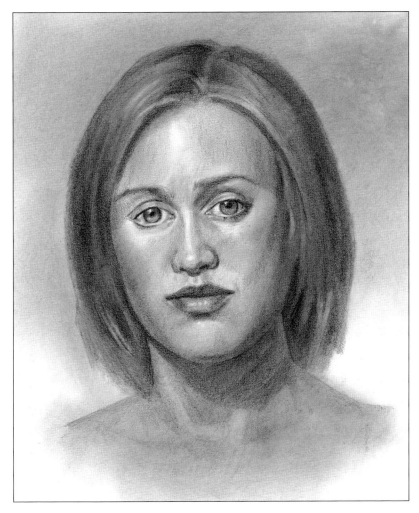

Negative Space Inaccuracies This artist draws details well but either doesn't know how to—or want to—spend time on the lay-in or plumb line stages; this is evident in that the mouth and eyes are too close to the nose. (Remember: The space between the forms is just as important as the forms themselves.) Of course, the artist should master stages 1 and 2 of the first three projects. But an artist like this also should try drawing the nose and comparing its size with the space around it, or he should check verticals up and down from the sides of the nostrils. He also should ask questions: Which is bigger—the lips or the space above the lips? Does this woman have a big jaw or a delicate one? So slow down, cowboy, and measure before you race ahead to the fun part.

A Note About Criticism

Beginners often are hurt by criticism, but professionals learn to love it. This is normal because beginners can easily be confused by bad advice, and because some criticism is wrong and some criticism is malicious. I've learned to always ask the model's opinion and listen to anyone whom I believe is objective. My work is 15 percent better because of this. Also, I'd rather hear an opinion when I'm still working than when the portrait is hanging on a gallery wall. So here are some tips for dealing with criticism:

(1) Solicit criticism; (2) try placing your drawing right next to the model's face—they should look the same; (3) try looking at your drawing in a mirror; (4) if you're with a group of artists, look at the model and your drawing in a small hand mirror; (5) step back; (6) squint; and (7) ask yourself questions: If the model is attractive, would you date your drawing? If the model is imposing, does your drawing intimidate? Remember that portraiture requires the most painstaking accuracy of all the visual arts.

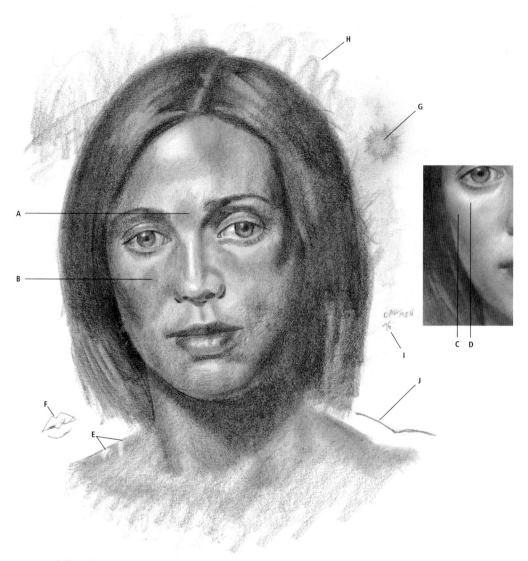

Overmodeling This poor artist is trying very hard to make the portrait look three-dimensional. So every time he sees a little plane change or depression on the surface, he shades very darkly—too darkly (A). This is called "overmodeling." He must understand that all the tones on the light side of the face must mass with the light. If they don't, they look like bruises. Furthermore, halftones aren't like islands that simply appear in the middle of the light side (B). They mass against the shadow side (C) and emerge from the core shadows, gradually lightening up to the highlight (D). The remedy is to squint and look back and forth between model and drawing. If you don't like squinting, then place your drawing next to the model and step back far enough to freshen your eye. These habits will reveal the true tonal pattern.

This artist is also habitually messy. Note where he decides it's not important to shade up to an edge (E). He leaves in diagrams— "it's just a study" (F). A drop of grease from the artist's sandwich (G). Instead of tone in the background, the letter "M" appears (H). He has even used his drawing as a notepad (I). Also, he doesn't fully erase his false starts (J).

A Word to Teachers

It's more important to remain patient than to get your point across. The students must never realize how upsetting their mistakes are to you. (If you didn't care, you wouldn't be upset.) Moreover, the reason I know these mistakes so well is that I've made them all.

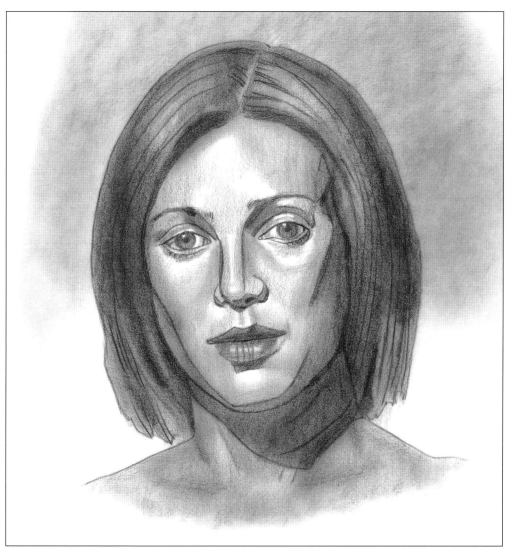

Outline Issues A percentage of every population will become "outliners." If you are trying to overcome this behavior, the first steps are to admit to yourself that you are an outliner, that people don't have outlines, and that lines are for plane changes on robots, not people.

The solution is to draw the sharpest edge (A); then draw the softest edge (B). All other edges must be between the two.

As for the silhouette, it's true that the forms have to come to a stop somewhere, so go ahead and draw a line—but shade up to it so it becomes lost (C), or draw it clearly but lightly, even fading it out (D).

After all that, if you still can't control your outlining habit, don't punish yourself with guilt. Nobody's perfect.

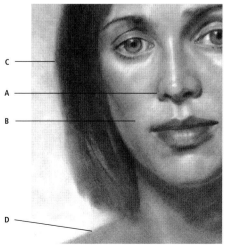

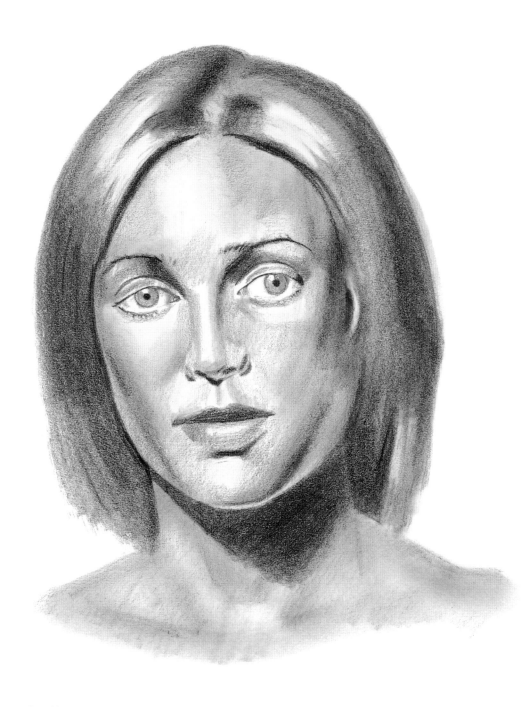

Tonal Problems When this fellow sees anything light, he makes it too light (for example, look at the highlights in the hair and the reflected light under the jaw). And when he comes to the "white of the eyes," guess what happens. The solution is for some well-meaning soul to put a piece of white paper next to Karolina's hair—the highlights in brown hair are light brown, not white. Reflected light isn't light in *tone*—it's still part of the shadow. *Remember: Nothing in the shadowed areas can be as light as anything in the direct light.* If you find that the reflected light under the chin is competing with the halftone on the front of the cheeks, you should worry. Squint—the reflected light will mass with the shadow. And please shade the "white" of the eye; the "white" of the eye is only an expression. Unfortunately, this student also makes his cast shadows black. I wear a black leather watchband that I put next to the model's cast shadows in class, whereupon I announce in a thunderous voice, "This is black," and it has the most marvelous effect.

More on Achieving Accurate Tone

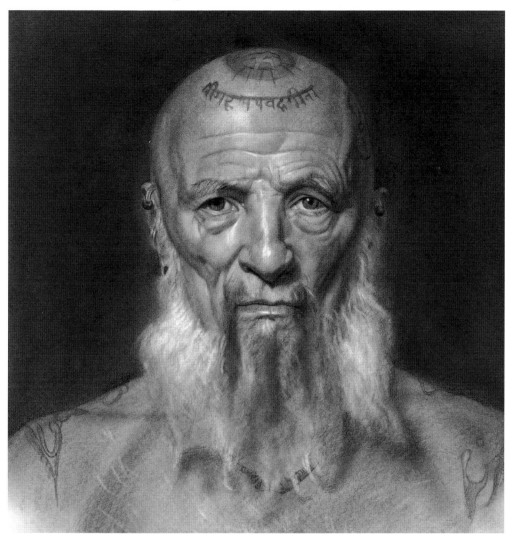

Using the "Egg Rule" Drawing Erl Van Aken would be troubling for a student because Erl's wealth of surface detail might break up his overall form. To avoid this, shade as if his forms were simple; then add the detail on top and shade again. While shading, continually remind yourself of the "egg rule"—the lightest area is at the top left, darkening as it goes down and to the sides of the egg. As the light source comes from the upper left, everything should be darker on the right.

▶ After decades of being an artist, I still remind myself of the "egg rule" as a basis for shading. The whole form is darker on the bottom right (A), so each smaller form is darker on its bottom right (B). The lightest area on the chin must be darker than the lightest area on the forehead.

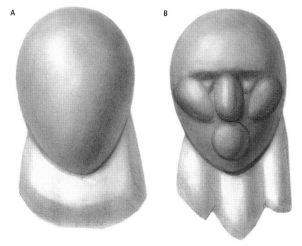

A B

INCLUDING A TORSO

Once the head is correct, it's easy to determine the proportions for the rest of the body. First hold out your arm and measure how many heads it takes to reach the waist. This gives you the appropriate length. (Remember that it's easier to adjust a form's width than its length.) Next it's vital, to estimate the body's width, to measure the breadth of the shoulders. Once you have the shoulders, you can run verticals down to see where the rest of the body aligns. Of course, you also should check verticals down from the sides of the head, the nose, and so on.

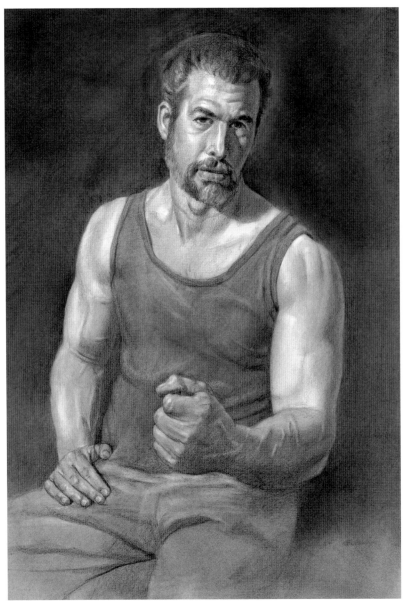

◄ Avoiding Distortion I sat only 4 feet from Rick, which created extreme *foreshortening* (the way objects closer to the viewer appear larger than those farther away) of the fist. This seemed acceptable because it added drama—and drama helps art. But if you want to avoid the apparent distortion of foreshortening, do the following:

1. Sit about 10 feet from your model, or far enough away that the proportions regularize.

2. Mark all the proportions (see page 55).

3. Creep forward when you need to see the details.

4. As you move forward, adjust the height of your chair so your line of sight remains constant. You must see the forms from the same angles.

Rick Rosner, one day

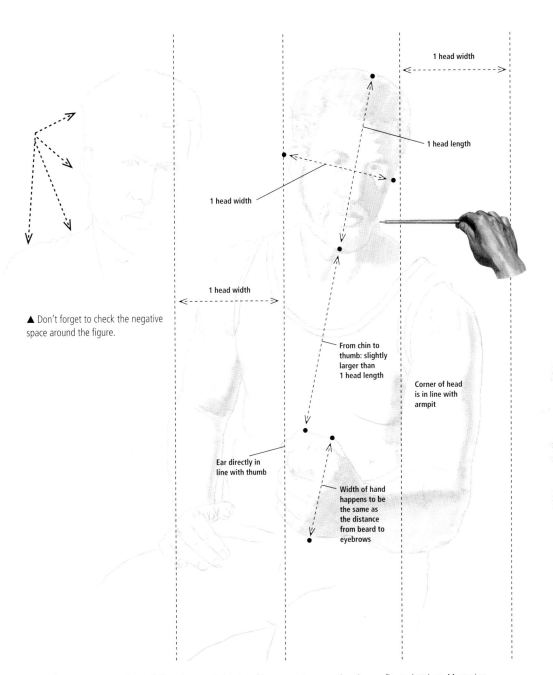

1 head width

1 head length

1 head width

1 head width

▲ Don't forget to check the negative space around the figure.

From chin to thumb: slightly larger than 1 head length

Corner of head is in line with armpit

Ear directly in line with thumb

Width of hand happens to be the same as the distance from beard to eyebrows

Mapping Out Proportions Follow the steps below to achieve accurate proportions in your figure drawings. Measuring carefully is especially important in a drawing with foreshortening—the size of this model's left fist is larger in proportion to the head than you may expect. Reflect these counter-intuitive measurements in your drawings to ensure accuracy.

1. To determine the width of the shoulders, compare them with the width of the head. Also look at the shape of the negative space.

2. Check verticals down from the shoulders and head to determine the rest of the body's locations.

3. Measure head lengths down for proportions. In 25 years, I have never drawn a single hand (or foot) without comparing it with the size of the head.

4. Ask yourself questions along the way. For example, which is longer—the distance from the shoulder to the neck or the distance from the neck to the top of the head?

WORKING WITHIN A LIMITED TIME

When drawing a head from life in a limited amount of time, you must make adjustments to the seven-stage process. Keep the following three points in mind as you draw: (1) You must draw at a smaller size: the final drawing on this page (bottom right) is shown at actual size and took an hour; (2) you should use 18-lb marker paper and rely less on the 9B and more on the 5B and 2B pencils (these are harder and better suited for small details); and (3) you must combine stages.

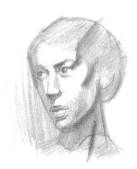

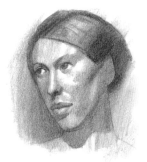

Stage 1 Create the lay-in, but leave out plumb lines and only check if you sense inaccuracy. Leave out the volume stage because you can imagine it as you draw around the edges and outlines.

Stage 2 Combine edges and outlines with the tonal pattern. Draw the outline, and then draw the opposite core shadow. Throw on the tone as you go back and forth. The main tone will help you decide where to put the next line. If the face has a lot of shadow, rely more on the tonal pattern. If not, rely more on outlines and edges.

Stage 3 Move on to finishing. "True up" the drawing from the previous stage by nailing down the darks and erasing to make adjustments as you go.

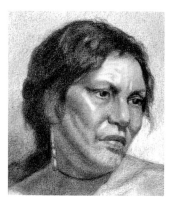

I began this portrait with a cube—do you see it? Notice how the model's slightly furrowed brow creates a sense of melancholy.

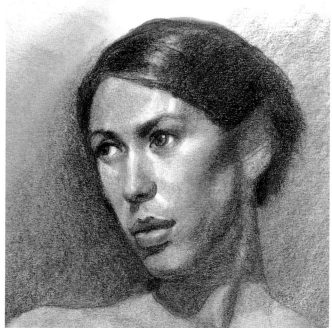

Stage 4 Darken, stump, and highlight like crazy to polish the drawing.

LAYING IN A PROFILE

Drawing a portrait in profile is less common than drawing one from a front or three-quarter view, and it requires a slightly different approach. Follow the stages below for a profile.

 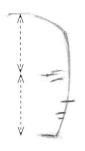 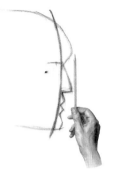 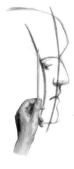

Stage 1 Try to discern a basic arc from the forehead to the chin, and put it down on paper. This is a guess that you will build on.

Stage 2 Extend your arm and measure to find the halfway point between the top and bottom. Mark it. Then guesstimate where the brow, bottom of the nose, lips, and so on fall on your arc. Now mark them.

Stage 3 Hold a pencil vertically to the model's silhouette and determine which form goes out farthest (e.g., brow or chin, upper lip or lower lip, etc.). Add them to the arc.

Stage 4 Hold the pencil vertically on the inner silhouette to compare the corner of the eye, the nostril, the mouth's corner, the neck, and so on. Place them correctly in relation to one another.

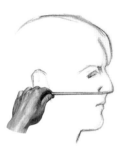 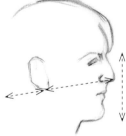

Stage 5 To place the ear, hold the pencil horizontally to check it against the base of the nose and the eyebrow. This will show you how high the ear should be.

Stage 6 Continuing to place the ear, extend your arm and measure the distance from the chin to the brow. Compare this with the distance from the nose tip to the earlobe. This will enable you to decide how far back to draw the ear. (Also measure from the lobe to the back of the head.)

▲ Notice that the high point of the head is not above the forehead. The top is near or behind the center of the head. Remember this fact when you draw a tilted head.

DRAWING BABIES

The only difficult thing about drawing babies is their radically different proportions. I urge you to memorize the diagram below and even draw it in lightly before you draw a baby, because you don't have much time for mistakes. I deal with a baby's movement by allowing ten minutes of drawing for every hour of waiting. But the wait is charming. I included a drawing from a photo (at right) because it makes perfect sense to use a camera for a baby. Photos usually are poorly lit, so remember to shade sensitively or the forms may look flat. Even without heavy shadow patterns, people still look three-dimensional—just use the lights and darks that are there, even if they're subtle.

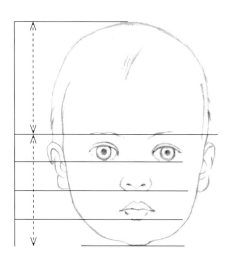

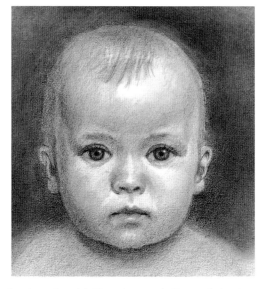

Baby Proportions The proportions of a baby are much different than those of an adult. The eyebrows are halfway up the head, the bottoms of the eyes are about three-eighths of the way up the head, the bottom of the nose is about one-fourth of the way up the head, and the bottom of the mouth is about one-eighth of the way up the head.

DRAWING OLDER PEOPLE

Seniors are excellent subjects for exploring texture and character. Notice how the side lighting on the model below brings out his craggy good looks.

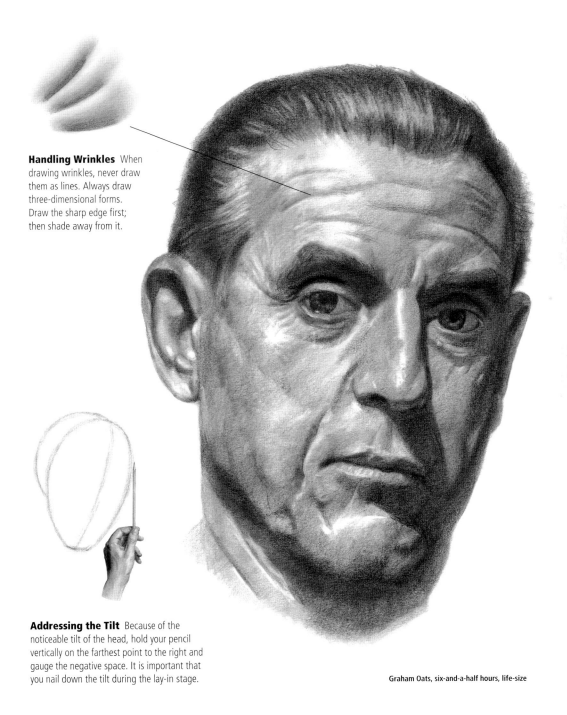

Handling Wrinkles When drawing wrinkles, never draw them as lines. Always draw three-dimensional forms. Draw the sharp edge first; then shade away from it.

Addressing the Tilt Because of the noticeable tilt of the head, hold your pencil vertically on the farthest point to the right and gauge the negative space. It is important that you nail down the tilt during the lay-in stage.

Graham Oats, six-and-a-half hours, life-size

DRAWING DIFFERENT RACES

Let's explore drawing different ethnicities. Drawing people of different races is neither more nor less challenging; this is because a portraitist can't rely on a formula. Each individual needs to be viewed as a new combination of shapes and forms. For example, if I drew sisters, I'd still have to carefully study each woman with a fresh eye, looking for her unique characteristics. Portraiture is a game of fractions of an inch. Familiarity isn't much help. Don't worry, though—eventually it becomes second nature to squint, check negative space, and measure the features against one another. The portraitist does this periodically throughout the drawing until the end. He or she delights in finding errors because every found error whittles down the portrait to a greater likeness.

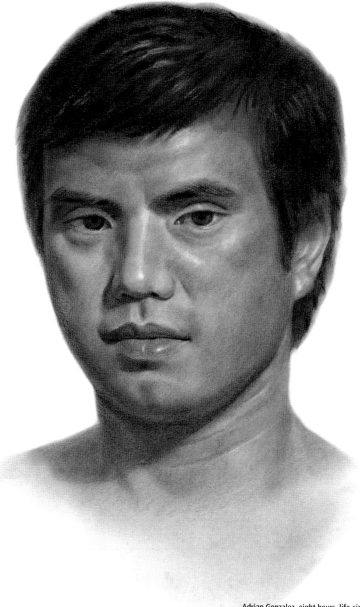

Asian The tricky part about drawing Adrian was replicating his inky black hair. For a small head, you can get away with grinding in a Staedtler® 8B for a quick black. But for a life-size head, lay the drawing flat, pour on the Design® Ebony Sketching Pencil (Matte Jet Black) powder, and rub it in with a powder puff and make-up applicator. Even then you still may have to grind in the pencil here and there for the darkest darks. Fortunately, the Staedtler® 8B stays matte while providing dark tones.

Adrian Gonzalez, eight hours, life-size

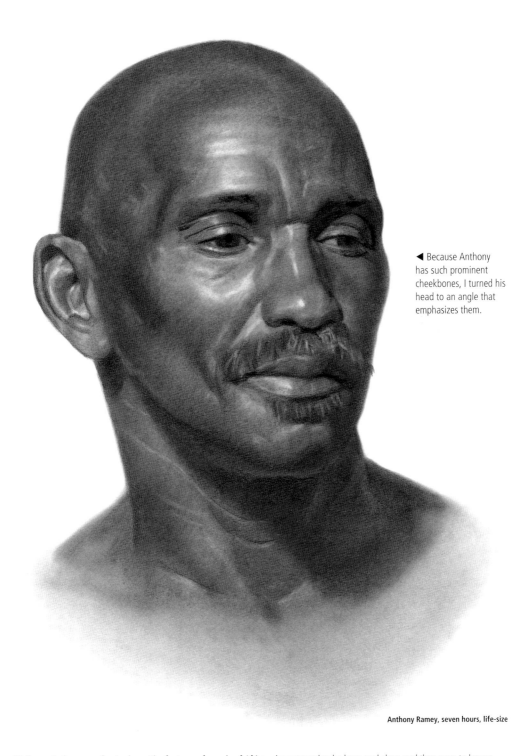

◄ Because Anthony has such prominent cheekbones, I turned his head to an angle that emphasizes them.

Anthony Ramey, seven hours, life-size

African Anthony was fun to draw. The features of people of African descent tend to be large and clear, and they seem to have a design that gives the drawing order. Shading is simpler too—just dark, very dark, and a few brilliant highlights. The danger for the student artist is rubbing too soon or shading chaotically. These mistakes will lead to a dark mess. Therefore, shade methodically, first addressing the whole head with halftone. Emphasize the edges of the core shadows and cast shadows. Then, when the structure is nailed down, you may rub and darken. Remember to shade either along the core or across it—multiple directions will result in a mess.

ARTISTIC PHILOSOPHY

Below is my drawing of *Portrait of Guillaume Guillon Lethiére* (after Ingres, who is rightly considered one of the greatest draftsmen of all time). Ingres's head drawing is particularly brilliant, but what most people don't realize is that there have been quite a few other artists who could draw heads just as well as Ingres. What made Ingres great was a full career of spectacular and moving drawings *and* paintings. His technical ability to draw a head surely has been equaled over the centuries by unknown artists in many countries.

The professional realizes that only a few artists will have spectacular careers, but anyone who has proper training and diligence should be able to master simple technical feats such as drawing heads. On the opposite page are four heads drawn by my students. Each student drew the head from life in less than five hours, and all of the students are in their early 20s. I include them here to show you that my seven-stage system works. In fact, these young artists are well on their way to surpassing their master—a day I dread.

One might object that my students' works look too much like mine and that the students copy my style. Nonsense! I teach them to accurately depict what they see. Reality looks about the same to all of us; consequently, their drawings look a lot like mine and one another's. What they ultimately *do* with the knowledge I impart will help them express their individual tastes and interests. Moreover, as an instructor, my only role is to pass on technical information. I never tamper with my students' ideas. That would truly inhibit creativity.

A Note to Aspiring Students

Some of you may be considering enrolling in an art school. Most art colleges today concentrate on theories and trends—if you want to simply keep up with the fads, you can save a fortune on tuition by just subscribing to a few art journals. But if you choose to go to an art school, remember that your education should stress drawing accurately. Before you can draw what you imagine, you must be able to draw what you see. Finally, keep your integrity upon graduation by drawing the themes and subjects that interest you, not those that interest your teachers.

Drawn by Nick Enevoldsen

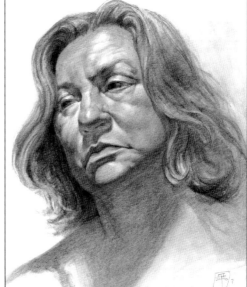

Drawn by Carolin Peters

Drawn by Adrienne Stein

Drawn by Rustam Khasanov

BEYOND PORTRAITURE

For some of you, mastering the methods in this book will be enough. But if your circumstances permit, I urge you to go forward. Although head drawing is a great foundation for a career, an expert must master the following subjects and focuses: figure drawing and anatomy, classical oil painting, perspective, and composition.

Approach figure drawing with practical, realistic methods like those described in this book. You can master the skill in a year at three sessions per week; you can learn anatomy by buying a comprehensive book and *gradually* memorizing it. Students also should build an *écorché* (an anatomical figure or sculpture) for reference. The easiest way to learn classical oil painting is to find an artist who appears to achieve genuine classical results. This may seem daunting, but try the internet. It's amazing that in every region there always seems to be a classical painter (wretched and obscure though he or she may be). Try to find a perspective class that's oriented to illustration—not engineering or architecture. To learn composition, read *several* books on the matter. Carefully study the work of the old masters, and experiment quite a bit with your own combinations of form and color. Good luck! (I also recommend prayer.) I hope your artistic endeavors will be fulfilling.

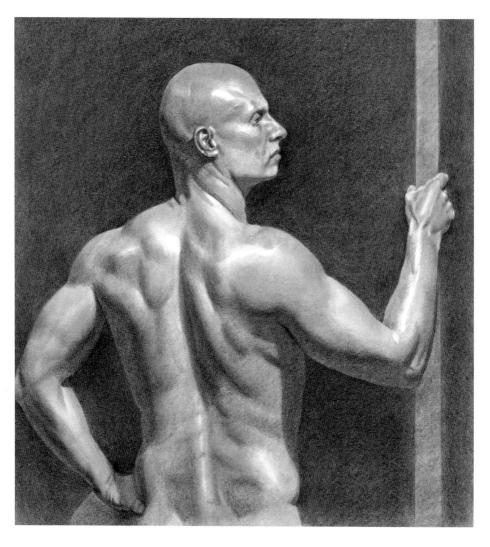